A Guide to Pre-Columbian Art

This guide was designed and produced by

A Guide
to Pre-Columbian Art

Foreword by
Carmen Fauria

Texts by
Jean Paul Barbier

museu barbier-mueller
art precolombí

barcelona

Conception
Jean Paul Barbier
Laurence Mattet
Eric Ghysels

Design
Marcello Francone

Layout
Fayçal Zaouali

Assistant editor
Maria Teresa Badalucco

Scientific editors
Carmen Fauria
Gillett Griffin

Cover
Mexico, *Aztec*, AD 1300–1521.
Basalt, ht. 37.5 cm.
Inv. 509-2.

Back cover
Mexico, *Maya*, 550–950 BC.
Terracotta, ht. 25.5 cm.
Inv. 502-6.

First published in Italy in 1998
by Skira Editore S.p.A.
Palazzo Casati Stampa
via Torino 61, 20123 Milano, Italy

© 1997, © 1999
by Musée Barbier-Mueller, Geneva
© 1997, © 1999
by Institut de Cultura de Barcelona
© 1997, © 1999
by Skira editore, Milan

Printed and bound in Italy. First edition

ISBN 88-8118-252-1

Distributed in North America and Latin
America by Abbeville Publishing Group,
22 Cortlandt Street, New York, NY
10007, USA..
Distributed elsewhere in the world
by Thames and Hudson Ltd.,
181a High Holborn, London
WC1V 7QX, United Kingdom.

Foreword

The Barbier-Mueller collection in Barcelona offers a unique opportunity to gain a closer view of the pre-Hispanic world. Unique, because this view is based on selected works which enable the visitor, even purely on a sensory level, to take in at a glance the complexity and the wealth of this world which Columbus described as 'New'. It is true that it was new, but only in the sense of being different from the world from which Columbus originated.
In reality, when the first Spaniards took possession of the fourth continent, they unknowingly entered into a universe of ancient wisdom, peopled by men and gods, who were linked by a complementary and integrated system. This created an interdependence which guaranteed the survival of both sides. An awareness of the natural environment was one of the natives' fundamental principles, as was an ability to make use of their surroundings while maintaining a respect for that of which they were part.
It was this combination which preserved unity and life, making the latter a source of constant renewal which had neither beginning nor end and therefore transcended the myths which attempted to explain it.
The Europeans stuck closely to their own origins in order to justify and survive the impact of the new world and, as a result, rejected any desire to learn. Their introduction of an anthropocentric view of the world and the confidence that the protection of a single, all-powerful God gave them, combined to banish autochthonous principles and to create an image of lost peoples, who were under-developed and almost savages. This image is still widespread today

and is at the origin of the corresponding lack of communication and ignorance. However, we need only look at the Barbier-Mueller collection (no long explanations are needed) to immediately discard this old image.

The collection highlights very clearly the intellectual and technical superiority of men who were capable of creating such beauty from the great diversity of materials at their disposal. The Barbier-Mueller collection was designed with the principle of the image as its starting point. Moreover, as people who are both owners and specialists have confirmed, in agreement with authors such as Georges Duby, 'a monument says at least as much as texts about what the people of its period were thinking and, by expressing it differently, even says more.' Taking these two points into account, it is indisputable that, in this case, this maxim fits perfectly.

It is in fact becoming possible to isolate art, separate it into subject and object and enclose it within its own aura. At the same time, art, with its richness and almost infinite variety of forms, provides numerous ways of showing off particular textures and making intelligent use of materials, as well as supplying arguments which offer constant justification of whichever option is chosen.

Our starting point, moreover, assumes a certain amount of isolation. Each work constitutes an end in itself and we can disregard the relationship linking it to other works which have stylistic or cultural affinities. There is therefore no intention to explain the people and the societies who created these works. The collector's know-how allows us to acknowledge each piece individually as a special and precious work of art. I believe, nevertheless, that the power which emanates from each of these pieces exceeds any attempt to isolate it. It is a source of fascination to its owner when he describes, almost reverently, each of its distinctive features. However, although we all agree that these are works of art, no one can deny the fact that they also represent far more.

Both the guide you are holding and a visit to the exhibition reveal that the works on show today have an integratory function. For example, the Olmec stone sculptures with their magnificent finishes, are, almost without seeming to be, part of any world vision. If the first Mesoamericans were capable of selecting, systematising and, finally, reflecting in their territory the influence of their predecessors and their contemporaries, they were equally visible — in ideology and form — in societies which subsequently

occupied the same area. After all, their mouths, with their great cat-like teeth, still provoke questions today.

The main axes of the collection correspond to the most well-known eras and groups of people: the Olmecs, Mayas and Aztecs in Mesoamerica; the Chavín, Mochicas and Incas in the Andes. Between these two axes we have the infinite variety and Baroque character that is found when quantity is combined with quality: Chupícuaro, the Mexican West, unknown Central American societies, remarkable for the form and colour and the inestimable amount of large clay receptacles in the Amazon region. The link between the Santarem zone and the inhabitants of the Caribbean or the possible, very ancient, relationship between the Pacific and Atlantic coasts, Valdivia and Marajo, add a note of dynamism, which is of course part of the objective inherent in any cultural proposal.

The possibilities offered by the Barcelona collection can be seen from two perspectives. The first is contemplative, introducing contemporary Western concepts of art for art's sake. Individualising the work is an important part of this. The second is closer to the origins of the art on show, subtly linking each moment and each proposal with its own co-ordinates of place and time.

Each of these proposals requires different approaches. Both, however, appeal to the Barcelona public, with the possibility of going beyond their perception of America, this Abya-Yala (land of maturity) defined by its ancient inhabitants. The concept that these people had of their country comes out as being very suggestive, just like their works.

Although, historically, Catalonia has been proven to share some areas of common ground with Latin America, the most ancient of these have never raised much interest. This could in fact be seen as a whole new area waiting to be discovered, particularly as regards the evidence which suggests that there was direct contact with the pre-Columbian world. A far more concrete approach to an understanding of autochthonous societies can be achieved through the correct use of local archaeological data, in combination with the documentary information brought by the first voyagers to step on the soil of the new continent.

Even the most well-known facts have an air of imprecision about them, such as in the case of Columbus' stay in Barcelona on his return from his first voyage. At the time, when the real extent of his discovery was as yet unknown, he came to the city to inform the

Catholic leaders about the progress of his enterprise, but also with the intention of preparing for a second expedition. The exoticism of the men he brought with him from the far-off Caribbean, the numerous samples of gold-work and craftsmanship, as well as tropical fruits, provided the best guarantee that his projects would continue.

Columbus provided a detailed description of his voyage for the leaders themselves as well as for people who, for economic reasons or because of their influence, were in a position to support him in his enterprise. At the same time, he also wrote about his experiences during his quest for Cipango, an exploration which led him to the beaches of the Bahamas. His writings were a great success: they were widely circulated and several editions were published, one of which was in Catalan.

The Catalan presence was already visible during Columbus' second voyage in the shape of the servicemen Pere Margarit and Miguel Ballester. A monk from Montserrat, Bernat Boil, also accompanied them, and we know that he initiated a long relationship between Montserrat and America. Testimonies to this link still exist today in the form of numerous sanctuaries devoted to the Virgin of Montserrat, often with a strong syncretic content.

Subsequently, economic trends in Catalonia led to the establishment of trade links and probably helped to reveal a relationship which dated back to ancient times but was perhaps covered up by the simplification of the fact that the conquest and colonisation were Castilian projects.

Eventually America became a refuge for Catalan political exiles, thus tightening the links existing with some countries, so much so that it has since been difficult to think of them as foreign.

The originality of the Barbier-Mueller collection in Barcelona may help to strengthen an ancient relationship through the impact of looking at some exceptional works, hand-made by men who lived at other latitudes. A first visit will undoubtedly be for aesthetic reasons. It will, however, provoke questions and the curiosity of a public who will seek responses from municipal institutions and from the owners of these works.

The Institute of Culture in Barcelona and Mr Barbier plan to create a platform for discussion and education about the ancient pre-Columbian world. This project requires a large arena in which to introduce to the audience a specific type of art, far removed from Western cultural models, and to present American archaeology and

ethnological history in a new light. This plan, now made possible by the availability of the Palau Nadal, restored and open to all, may help to unite the uncoordinated projects working in this area and to lay the foundations of a solid relationship between Barcelona and the lands of the mythical Fourth Continent, starting from an understanding of the past and progressing towards an understanding of the present.

Carmen Fauria
Director of the Barcelona Museum of Ethnology

It is not known what the peoples who built these civilisations called themselves: the civilisations have themselves been named after the main sites where they were found. For the sake of convenience, we will use the names of these sites to refer to their people, thus: the Teotihuacán, the Chavín, the Hopewell, etc.

Some dates are definite, with a known margin of error when they are checked scientifically, in particular when using certain radioactive sources such as the isotope C14 for bones or wood or thermoluminescence for clay. It is more difficult to date stone monuments, especially without the assistance of wooden sculptures in an identical style or human remains clearly associated with the monument. This is, for example, the case with numerous stone figurines in Mezcala style, found in the State of Guerrero (Mexico) by peasants. Archaeology is constantly providing new data. The dates of the first human settlements in the Americas, the first attempts at agriculture and the first ceramics are regularly reviewed.

More detailed explanations and a copy of the photographs of all the pieces on exhibition in the Museu Barbier-Mueller d'Arte precolombino in Barcelona can be found in the book *Ritual Arts of the New World* published by Skira. Contributors include specialists on each region.

Contents

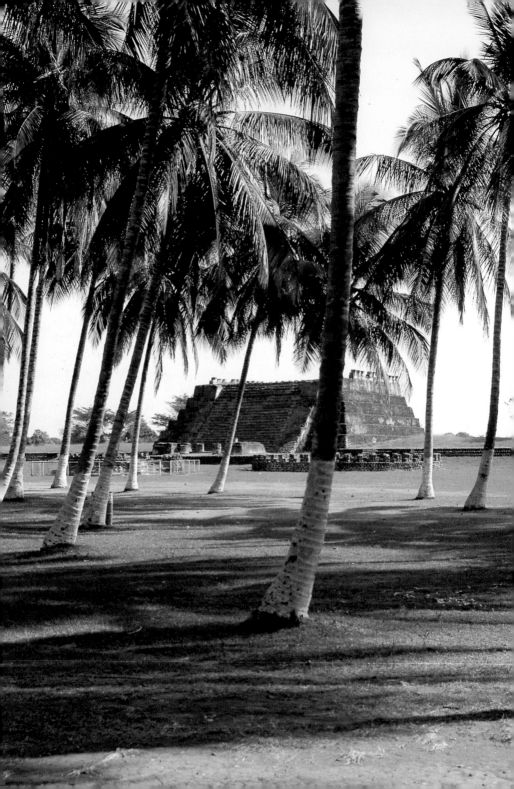

Introduction

The earliest signs of human life in the New World were found in Lewisville, Texas, dating back some 38,000 years. Archaeologists continue to make new discoveries however. It is possible that immigrants from Asia crossed the Bering Strait earlier, during the Ice Age, without getting their feet wet. During the so-called 'Pleistocene' age, these immigrants would have coexisted in America with animals such as mammoths, mastodons and horses.

Since the end of the last Ice Age, in the 'Holocene' period about 10,000 years ago, both Americas have been populated in their entirety. Mammoths, horses (which were reintroduced by the Spaniards in the 16th century) and other animals of the 'Pleistocene' age had disappeared, but the dog, now domesticated, was in evidence. The people who lived in the encampments or rudimentary houses which we are now finding were still hunter-gatherers and knew nothing about the art of ceramics until the 4th millennium BC. It appears that agriculture developed earlier in the Andes than in Mesoamerica. We have proof that the potato was being cultivated in the north of Bolivia around 8000 BC. This was followed by squash, beans, peppers, etc. Maize cultivation starts in Mexico in about 4000 BC, having been preceded by the cultivation of gourds. Broadly speaking, it would be correct to say that agriculture came before ceramics. It is probable that people have been taking hallucinogenic substances (mushrooms, drinks made from plants) since the very earliest times. Such rituals seem to indicate that shamans, not just magicians, were widespread.

All the dates concerning the origins of agriculture and ceramics are

Fig. 1
Pyramid of the Chimneys in Cempoala, the first pre-Columbian monument to have been seen by a European, Cortez, who stayed in the temple which used to be at the top of the pyramid.
Photo Jean Paul Barbier.

under constant scrutiny. Fragments of pots dating back to 4000 BC were recently found, for example, in Brazil.

In the following chapters we have limited ourselves to a brief description of the main local cultures. Many of these deserve to be called 'civilisations', in the etymological sense of the word, as they built actual cities or urban areas, although only religious buildings and palaces of princes and high priests were, at least partly, built in durable materials. The most ancient cultures date from the 'preclassic' or 'formative' period (1300 BC to AD 200), the most brilliant (such as those of the Mayas, of Teotihuacán or Tiahuanaco) come approximatively from the 'classic' period (AD 200–1000) or (like the Aztecs and the Incas) the 'postclassic' period (AD 1000–1500). Our understanding of these civilisations, based on 'works of art' which have come down to us (all of which had a religious or magical as well as a decorative role), is inevitably incomplete. It does not, for example, take into account the extraordinary achievements of the Mayas in mathematics, astrology, civil and other engineering. The works of art themselves tell us only part of the message they contain. We know nothing about the mystical or sacred context of which they were a part because, unlike Egypt and Greece, the American civilisations, with the exception of the Maya, left us no texts.

We should not despair however at this barrier between us and these works. Their beauty owed nothing to chance but had a sought-after purpose and use, as the instrument of a cult or a magical rite. As human beings we cannot fail to appreciate this search for 'Beauty': we are unconsciously worshipping the 'God of Beauty' every day, whether it be in choosing an item of clothing, a tool or a piece of furniture.

Faith has never transformed an amateur painter into a genius. The Mesoamerican potters and sculptors were not all equally gifted. The works presented here are not beautiful by chance. There are plenty of urns from Monte Albán and statuettes from Chupícuaro whose workmanship is mediocre. We propose to draw a deliberate distinction between ourselves and the extremely useful and respectable objective of the ethnographical museum, which displays objects of scientific educational value. Our intention is rather to focus on the plastic qualities of creations without of course forgetting the circumstances in which they were created. Hence the explanations provided in this Guide.

We have not thought it necessary to concentrate on the recent

Fig. 2
Our knowledge and appreciation of the pre-Columbian cultures should be enhanced over the next few decades by the increasing numbers of systematic, scientifically monitored archaeological digs in Latin America. This is an unexcavated site in Cocoxtlán (Puebla State, Mexico). Photo Jean Paul Barbier.

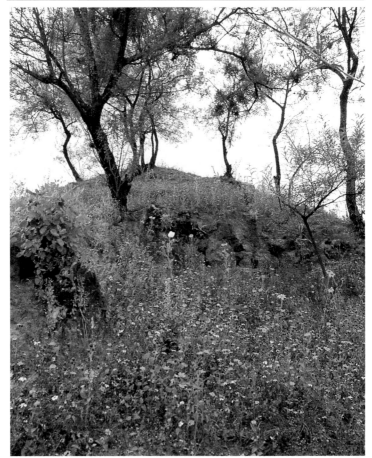

attempts to decipher the Maya hieroglyphics, nor on the rare texts (Maya or Mixtec codices) which have miraculously survived and show that the New World was already moving towards keeping a written record of its history, and even towards producing its own literature. We share Georges Duby's belief that 'a monument says at least as much as texts about what the people of its period were thinking and, by expressing it differently, even says more.'

15

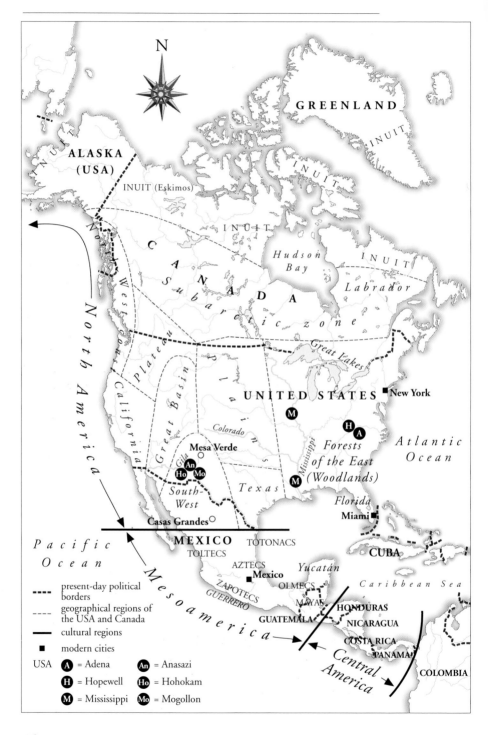

N

GREENLAND

INUIT

ALASKA
(USA)

INUIT

INUIT (Eskimos)

INUIT

North America

North West Coast

C
A
N
A
D
A

Subarctic zone

Hudson
Bay

INUIT

Labrador

Great Lakes

Plateau

Plains

California

Great Basin

UNITED STATES ■ New York

Ⓜ

Ⓗ
Ⓐ

Colorado

Mississippi

Mesa Verde ○

Ⓐn
Ho **Mo**

*Forests
of the East
(Woodlands)*

Atlantic
Ocean

Gila

South-
West

Texas

Ⓜ

Casas Grandes ○

Florida

Miami ■

Pacific
Ocean

MEXICO TOTONACS

TOLTECS

CUBA

Mesoamerica

AZTECS

ZAPOTECS

■ Mexico

Yucatán

Caribbean Sea

GUERRERO

OLMECS

MAYAS HONDURAS

GUATEMALA

NICARAGUA

COSTA RICA

*Central
America*

PANAMA

COLOMBIA

- - - present-day political
borders

- - - geographical regions of
the USA and Canada

—— cultural regions

■ modern cities

USA Ⓐ = Adena Ⓐn = Anasazi

Ⓗ = Hopewell Ho = Hohokam

Ⓜ = Mississippi Mo = Mogollon

16

I. Archaeology of the United States

North America is divided into eight regions (see map Fig. 3), the most northerly being the vast zone which is home to the Inuits or Eskimos, believed to be the last arrivals on the new continent, having come from Siberia across the Bering Strait. During the past few decades, experts have discovered some small sculptures made in sea ivory (walrus teeth), of great plastic quality, which have come to light as a result of some lucky finds, archaeological excavations, and exhibitions. The earliest date back to the 1st millennium BC. Others are spread through the centuries (Fig. 4) following the start of the Christian period. They are at the origin of an artistic tradition which has continued until the modern period, and stands out because of its remarkable masks in light wood, which seem almost to have actually lived in ancient times.

Among the regions within the borders of present-day United States of America, the richest in terms of culture are those of the Great Forests (Woodlands) in the East, and the South-West.

The Forests of the East
The prehistory of this region included an 'archaic' period which lasted from 8000 to 1000 BC. Since the 3rd millennium, beautiful stone artefacts started to appear in the form of bow ties ('bannerstones') and birds ('birdstones'). The latter were remarkable little sculptures used as weights to balance spear throwers (*atlatl*) and made of stones covered in beautiful designs. Towards the end of the period, ceramics appeared in the form of human figurines on a site known as Poverty Point, in northern Louisiana: mounds can be seen here which may have been platforms forming the base for a temple,

Fig. 3
Map.

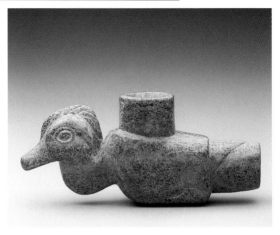

a frequent set-up in Mesoamerica. Most noticeable is the continued existence since 3000 BC of objects made using the technique of hammering nuggets of native copper. We cannot however really call this a 'metal technique' as the copper was not melted, nor was it alloyed with any other metals.

The so-called 'Woodlands' culture emerged in certain places before the end of the 'archaic' period. The 'Adena' complex in the upper valley of Ohio began about 1000 BC. Ceramic vessels were common, as were stone pipes, the bowl of which sometimes depicted a man, as is the case with the so-called 'goitrous' pipe, kept in the Museum in Columbus, Ohio.

From 100 BC until AD 70, the 'middle' period of the Woodlands was characterised by the 'Hopewell' culture, named after a site in Ohio. This culture extended over a vast area, to groups who shared the same religious beliefs but not the same language. Beautiful argil statuettes came together with extraordinary ritual objects, with eagles' talons or hands cut in sheets of mica. The mounds had a funerary purpose, some having been crowned with an altar or a temple. The stone pipes came in numerous forms. These include animals carved in a round shape, their bodies forming the bowl and the stem. The platform, on which the animal had been placed in the previous period, gradually disappeared (Fig. 5).

The final phase in the cultural development of Woodlands culminated roughly between AD 800 and 1600. This was the so-called 'Mississippian' phase. Agriculture was by now highly developed and maize had become a staple part of the diet up to the North-East, where a species of maize resistant to the cold was created by

Fig. 4
Statuette from fossilised sea ivory, depicting a person with a simplified body. Alaska, Inuits. Around AD 800–1000. Height: 20 cm. Inv. 901.

Fig. 5
Pipe sculpted in shale, the bowl emerging from the back of a bird. Tobacco use had been imported from Mexico to the Forests of the East in about 1000 BC. Tennessee. Around AD 500–1000. Length: 19 cm. Inv. 970-8.

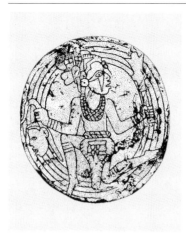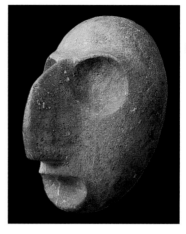

Fig. 6
Disc made of shell with engraving depicting a warrior holding a severed head in his right hand. 'Mississippian' culture. Around AD 1200–1500. Museum of the American Indian, New York.

Fig. 7
Pseudo-mask in stone. 'Mississippian' culture. Originating in Tennessee. Around AD 1000–1500. Former John Hewett collection, London. Height: 16 cm. Inv. 970-2.

hybridization. Mexican influence is evident, be it in the huge temple mounds (such as the one in Cahokia in Illinois, a rectangle of two hundred metres by three hundred metres) or in the decor of shell-shaped discs used as pectorals (Fig. 6).

Round stone sculptures, naturalist in style, and anthropomorphic vases depicting people or severed heads show the skill of the Mississippian artists. They are unfortunately little known among the general public because, unlike Mexican or Peruvian sculptures, these works are only well represented in American museums. Some rare 'masks' (Fig. 7) which seem too heavy to have been used as pendants despite their single hole for hanging them, complete a picture reduced here to its barest outline.

The Plains

The Great Plains in the centre of the country were very far behind, culturally speaking, in comparison with the Forests of the East. The Mississippian influence made itself felt here. The Indians were for the most part sedentary cultivators. It was only after the 16th century, when they were able to buy (or steal) horses brought by the Spanish, that they started to breed the animals, transforming themselves into bison-hunting nomads and establishing themselves as the brilliant horsemen and brave warriors in feathered headdresses of literary fame.

Their art consisted in particular of hide paintings of famous events, and costumes and clothes covered with glass bead decoration, which replaced the mosaics created using dyed porcupine quills (quillwork). Some tribes however, such as the Sioux, sculpted pipes from

19

soft stone, thus continuing the old Woodlands tradition. The bowls depicted people and animals.

The South-West

Around 10,000 BC, the area of the Great Basin between the Rocky Mountains and Sierra Nevada became more and more arid. Around 8000 BC the 'Desert' culture was that of typical hunter-gatherers. These people were also excellent basket makers and, from 2000 BC onwards, they developed a specific technique (still used), consisting of fixing strands of wicker on top of each other, and then enclosing them in a coiled-up strip of wicker.

Animal skin blankets, bows and arrows (unknown during this early period in the Woodlands and the Plains) were characteristic of these ancestors of the historical Shoshonis and Paiutes. They were not yet agriculturalists, nor had they discovered the art of ceramics.

This 'Desert' culture was without a doubt at the origin of the diverse civilisations of the South-West and even, according to some authors, of the rest of Mesoamerica. There was probably some contact with the inhabitants of the Mexican Altiplano, from whom they would have learned the cultivation of gourds and maize and eventually the art of firing clay. The earliest ceramics known to us, found in Vakki in Arizona, only date back to 300 BC however.

At this time, southern California and western Arizona were dominated by the 'Hakataya' culture. The existence of ball-courts for the ritual game of pelota indicates the Mexican influence in this area. This culture is less well known than the 'Mogollon' culture, which emerged around 200 BC between South-East Arizona and southern New Mexico and disappeared completely by about AD 1250. The Mogollons were mediocre farmers and lived essentially from gathering and hunting. Their villages were small and their circular houses partially buried. About AD 500, large *kivas* (underground holy chambers) replaced the small hollowed chambers for the purposes of the cult.

The Mogollons borrowed these from their neighbours to the north, the Anasazis.

In about the year AD 800, a remarkable tradition of beige ceramics with bistre-coloured (blackish-brown) or black decoration appeared in the valley of the Rio Mimbres, in southern New Mexico. In about AD 1000, this gave way to pottery with a less subtle, sometimes coloured decoration. Mimbre bowls depicted hunting scenes, or animals and human beings making religious gestures (Fig. 8). These

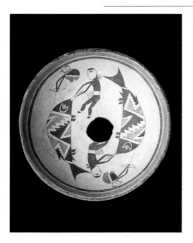

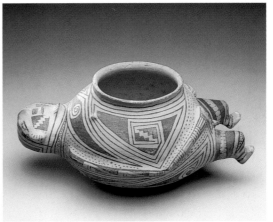

Fig. 8
Ceramic bowl depicting two figures holding some fish which look like swordfish. Style of the Rio Mimbres. 'Mogollon' culture. New Mexico, USA. About AD 850–1000. Diameter: 25.1 cm. Inv. 970-14.

Fig. 9
Vase in the form of a reclining figure. Style of Casas Grandes, in the state of Chihuahua (Mexico). The geometric style of the decoration indicates a relation to that of some mimbre bowls. AD 900–1300. Length: 36.5 cm. Inv. 970-12.

bowls were very often ritually 'killed', by being broken or pierced with a hole before being deposited in tombs.

Another extension of the cultures of the South-West was the urbanisation which left important ruins in Casas Grandes in the Mexican state of Chihuahua. Some original polychrome ceramics have been found there (Fig. 9).

It is generally agreed that our final subjects in this area, the United States Mogollons, were the forefathers of the present-day Zuni tribe, whose faithfully preserved costumes help us to better understand the past.

West of the Mogollons, near the city of Phoenix in the Sonora desert, the remains of villages belonging to the 'Hohokam' culture can still be seen. In the last centuries of the 1st millennium BC, pottery was very simple. It became more refined as a result of cross-breeding with Anasazi immigrants. This gave birth (for example) to the 'Salado' culture (Fig. 10) to whom we owe the palace of Casa Grande, several storeys high, in Arizona (not to be confused with Casas Grandes, mentioned above). The Hohokams had mounds with platforms, ball-courts for pelota and, most significantly, they had built huge irrigation canals, thus enabling these determined agriculturists to cultivate the desert. These were the ancestors of the Pima and Papagos Indians.

We will end this brief overview with a look at the 'Anasazi' culture, which had its roots in the most ancient traditions. Around 700 BC, the 'Vanniers', probably a branch of the 'Desert' culture occupied the south of Utah and Colorado. They knew nothing about ceramics, or the bow of their Mogollon neighbours, and lived in huts until

21

Fig. 10
Ceramic cup with
ochre background
and black decoration.
This decoration
depicts stylised
jaguars or snakes.
Salado culture.
Arizona. Gila River.
About AD
1000–1200.
Diameter: 21.8 cm.
Inv. 970-11.

Fig. 11
Small white ceramic
jar with black
decoration. Anasazi
culture. Tularosa
style. New Mexico.
AD 1200–1300.
Height: 18.8 cm.
Inv. 970-15.

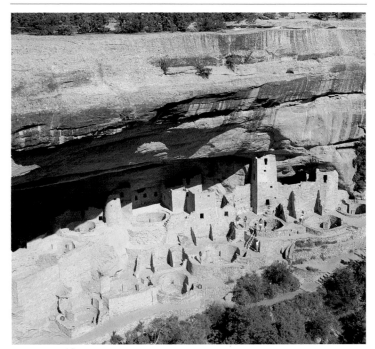

quite late, about AD 400, at which time pit houses started to appear. Significant developments in both pottery (Fig. 11) and agriculture also occurred at this time.

About AD 700, the pit houses disappeared, but the habit was retained of digging large underground halls for holding religious meetings. These were the *kivas* which can be seen in a ruined settlement, such as the one in Mesa Verde (Fig. 12) or that of Pueblo Bonito, one of the nine towns which run along the Chaco Canyon. It has been estimated that in around AD 1100, there were six thousand people living in these cities in the Canyon, where houses several storeys high were separated by the circular orifices of the holy chambers, or *kivas*. These are still used today by the Hopis. The Hopis also still perpetuate their tradition of making ceramics, as do the descendants of the Anasazis, the Pueblo Indians of the Rio Grande valley. The latter have recently produced some extremely talented potters, such as the famous Maria Martinez from Santo Domingo Pueblo, thus revitalising their ancestral inspiration.

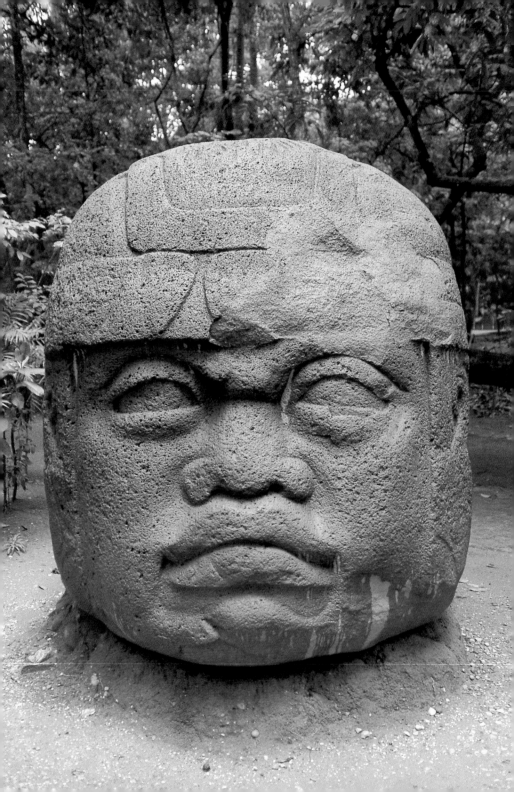

II. The Olmec Horizon
The origin of Mexican civilisations

In the second half of the 2nd millennium BC (see map Fig. 14), the region bordering the gulf of Mexico saw the development of a civilisation that has often been called the 'mother' culture of Mesoamerica. Without the aid of any metal tools, a forgotten people erected gigantic and magnificent monuments to its leaders and unknown gods.

The intricate workmanship, realism and power of expression of these monuments is astounding.

Some twenty-eight centuries before Cortéz and his soldiers destroyed Moctezuma's empire and, in the same stroke, the traditions which made Mexico a land of high culture, a strange revolution took place in the marshy lands and hills situated between the modern cities of Veracruz and Villahermosa.

Modest farming villages found themselves abruptly subjugated to the authority of princes, who may have been endowed with religious powers. The magnificent colossal stone heads (Fig. 13) are believed to be portraits of these princes (17 have so far been discovered). Where did this class of leaders come from? Were they a group of new arrivals or had they come from leaders of native villages, one of which succeeded in dominating? We have no answers to these questions.

In each case, whether it was a sudden eruption of gifted individuals or the maturing of a local family of hereditary leaders, we cannot explain the very rapid development of both the desire and the art of creating sculptures of astonishing size and beauty, without any preliminary tests or experimentation.

The Olmec sites have revealed statues and 'thrones' (even called 'altars'), as well as the monumental stone heads. These heads were

Fig. 13
The colossal heads, probably portraits of hereditary leaders, appeared during the early 'preclassic' period and would have been erected between 1200 and 950 BC. Some are wearing a cap like those worn by the participants in the holy game of ball, or pelota. La Venta. Photo Jean Paul Barbier.

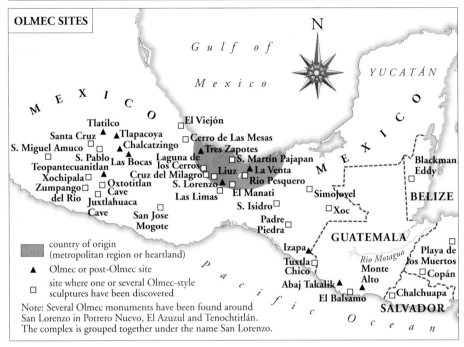

Fig. 14
Map.

sculpted in blocks of basalt weighing several tons and would have had to be transported dozens of miles from the quarries.

The Olmec Enigma

We do not know their real name: 'Olmec' is a nahua term (the language of the Aztecs), which can be translated approximately as 'the ones from the Caoutchouc region'. We have, however, no reason to believe that the present-day villagers of this coastal region are the descendants of those who built the sanctuaries of San Lorenzo, Tres Zapotes or La Venta. Basing his ideas on the vaguely negroid appearance of the giant heads, the journalist José Maria Melgar, who reported the first head in Tres Zapotes (Hueyapan), suggested in 1869 that we should consider Olmecs as 'Ethiopians'. Such propositions have regularly arisen up to the present day. Even Thor Heyerdahl temporarily abandoned his research on the populating of the Pacific Ocean to try to prove that the Mexican pyramids had been built by Egyptian sailors who had strayed off course! Some theories, by no means completely improbable, would like to make the Mayas the direct heirs of the Olmecs, seeing them as the proto-Mayas. These theories arise from a simplification which needs

to be backed up by archaeological proofs. There was a gap of several centuries between the abandonment of these purely Olmec sites in the region of the Gulf and the emergence of the Maya civilisation, and during this time the Olmec innovations changed and matured.

Rediscovery of the Olmecs

Curiously enough, the announcement of Melgar's discovery of the colossal head of Tres Zapotes did not give rise to any systematic archaeological research programmes, nor did the news in 1926 that several monuments had been found scattered around the same region, including another giant head in La Venta. In 1938 the American archaeologist Matthew Stirling went on horseback to Tres Zapotes to see Melgar's head and found it still in the same place, buried under tropical vegetation. Ten years ago, the author of this account also had the opportunity to see it, not without some emotion, sheltered under a miserable-looking corrugated iron roof near a large village in the middle of sparsely forested hills, dotted with hamlets of huts and cabins. Stirling took photos of it and on his return to Washington enlisted the support of the *National Geographic Magazine*. This was the beginning of a series of archaeological expeditions in the course of which Stirling visited the three main sites of the Olmec 'metropolitan' region: Tres Zapotes, San Lorenzo (and its neighbourhood) and La Venta. By this time, one discovery was following hot on the heels of another.

In 1942, a 'round table' was organised in Mexico to take stock of the situation. The Maya specialists had no intention of letting the Olmecologists take the Mayas' privileged position as inventors of the calendar, writing and the first dated commemorative stelae. The war between the scholars continued until the fifties when an analysis carried out by the so-called 'carbon-14' dating method put an end to the debate. Samples taken from San Lorenzo were dated at around the 13th century BC. La Venta proved to be a little more recent. The Olmecs had therefore sculpted their great heads over a thousand years before the Mayas had erected their first stelae (which were based on Olmec experiments) or built their first temples and stone palaces. It was no longer possible for anyone to contest the Olmec's entitlement to primacy, a position which the Peruvian civilisation of Chavín, more or less their contemporaries, enjoy in South America.

The Olmec City-Sanctuaries

We are still a long way from having an overall view of all the sites

scattered about this 'origin' or 'metropolitan' region (see map Fig. 14). The American Olmecists have called it the 'heartland', contradicting those of their colleagues who think that the Olmec civilisation was born on the Pacific coast, or in the centre of the country. We know of forty sites, which have revealed over two hundred magnificent monuments, as well as statuettes, masks, pendants in hard stone and other small artefacts.

The work, carried out by Stirling in La Venta and Michael Coe in San Lorenzo, has enabled us to imagine what the main Olmec sites in the heartland were like. San Lorenzo was certainly inhabited from halfway through the 2nd millennium BC but, as archaeological studies uncovered in 1966, it was about the year 1200 BC that the huge-scale excavation works began. An artificial plateau 1200-metres long rose fifty metres above the surrounding savannah. The ravines alongside it, like the plateau itself, were manmade but we do not know what they were used for. The whole site was covered with stone drains resembling a Roman sewerage system, in carefully assembled blocks, and includes a succession of *lagunas* (reservoirs). Mounds are dotted all over the plateau, sites for ancient constructions such as temples or houses for local dignitaries and privileged artisans. It would obviously only have been possible to develop such a citadel as San Lorenzo and build its stone monuments, by mobilising a sizeable workforce. The leaders (who may also have assumed the function of temporal priests in charge of cults about which we know nothing) would have needed remarkable authority over the small population of peasants who were scattered all around the artificially raised plateau, for it to be as developed and decorated as it was. We know very well that it would have taken the efforts of thousands of men to slide along the huge stone blocks, on wooden sledges, for dozens of miles. This implies, wherever it is done, a fervour which trascends the authority of a despot.

What happened about 900 BC, which caused the statues of San Lorenzo to be attacked with hammers, beheaded, overturned and the monumental heads hurled down to the bottom of ravines? A revolt by a mob tired of the growing demands of those leading them, a raid by an enemy neighbour, a change of dynasty?

Whatever the answer, the phenomenon was not widespread, nor was it followed by an invasion of the entire 'metropolitan region'. At the time when the site of San Lorenzo was abandoned, that of La Venta, some eighty kilometres to the South-East, was prospering. This four-kilometre long 'island', emerging from the marshes, had also been

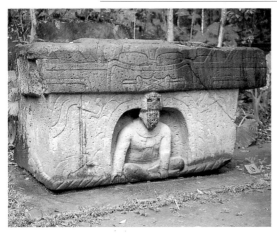 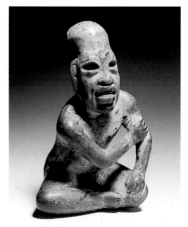

Fig. 15
This 'altar', or throne, carved from one very heavy block of stone, depicts a person seated, emerging from a sort of cave. Sometimes eyes and fangs were added on top of the cave to mark it as the Earth Monster, the cave being its mouth. La Venta. Photo Jean-Louis Sosna.

Fig. 16
Figurine in serpentine depicting a wrestler or, more probably, a ball player. Veracruz. 8th or 6th century BC. Height: 10 cm. Inv. 501-4.

raised and developed through excavation works, although it is true that these were less extensive than those in San Lorenzo. These developments began later — about the year 1000 BC — but here again, sculptors and engineers provided immediate evidence of their exceptional skill. A series of huge basalt heads (see Fig. 13) were erected early on, no doubt at the same time as the construction of a number of large-scale monuments, such as 'thrones', actually sacred thrones (Fig. 15). Heads and thrones exist elsewhere, in other Olmec sites, even if most are at La Venta.

The most significant discovery here is of charming figurines (Fig. 16), mixed in with bones reduced by time to powder (as is the case in an astonishing tomb made of basalt columns, a unique example of stone architecture in La Venta). Some were simply buried in carefully constructed caches, such as the one recently discovered by chance in the Rio Pesquero, which contained dozens, if not hundreds, of precious hard stone artefacts. The translucid blue or green jade, probably imported from the valley of the Motagua in Guatemala, certainly had a symbolic religious value. Statuettes and masks (some may have been placed on the face of a dead official or dignitary, while others were pendants) accompanied jewels (earrings, pendants, labrets) patiently sculpted from the most beautiful stones. Their style would persist through empires and invasions until the arrival of the Spaniards.

In San Lorenzo, in contrast to La Venta, we have found practically none of these precious jade objects, nor any statuettes in hard stone. This leads us to believe that this refined art developed after the year 900 BC.

The absence of any written document other than a few hieroglyphs engraved on the stelae or statuettes (we have manuscripts for the Mayas, the 'codices' collected by the Spanish) prevents us from learning much more about the social, political and religious organisation of the Olmecs. What is certain is that the Olmecs worked toward a calendar and a system of writing that the Mayas would perfect, as will be seen in a later chapter devoted to them.

Architecture and Olmec Art

Imagine the architectural configurations of San Lorenzo or La Venta before the wind and the torrential tropical rains came to wash away the mounds, terraces and monumental staircases of hard clay and rough bricks. In places we can guess what they looked like. Obviously, many of these mounds were bases for temples, which, because of the scarcity of materials for solid constructions such as stone, were not robust enough to last through the centuries. All building work relied on wood. The sculptors, who would have had great difficulty in cutting and shaping the bas-relief decoration on the thrones and the stelae we have found, should have had no trouble in squaring off the trunks provided in abundance by the surrounding forest, and in building major buildings. It is well-known that a stone axe is almost as effective as one made of bronze and that iron (unknown to native Americans) is the only material that makes better tools. The wooden pillars were undoubtedly covered in mythological scenes and symbols similar to those that we know from the stone bas-reliefs; semi-human and semi-feline figures, serpents with mouths open fiercely, signs (such as the Saint Andrew's cross) with sacred or magical connotations.

We are also in no doubt about the existence in these wooden temples, victims of the intense tropical humidity, of wooden sculptures and artefacts (a wooden Olmec mask is preserved in New York). Everything has disappeared, with rare exceptions such as the life-size human busts in pure Olmec style, which were discovered in 1988 in the mud of a swamp in El Manatí, not far from San Lorenzo.

There is a similar shortage of artefacts made of terracotta (Fig. 18), both those used for religious rites and for domestic use. In contrast to the centre of the country where such objects are in plentiful supply and provide ample evidence of the refinement of the Olmecs, in the 'metropolitan' region only fragments have been found. Pottery is no better at surviving the humidity and acidity of the soil than human bones. We have however been able to use some slivers to

Fig. 17
Left, pottery figurine in the 'Pretty Lady' style, typical of the site of Tlatilco in the suburbs of Mexico City. Early 'preclassic' period. 1200–950 BC. Height: 6.5 cm. Inv. 500-10.
Right, pottery figurine illustrating the 'Xochipala style', in the state of Guerrero. Early 'preclassic' period. 1200–800 BC. Height: 9.7 cm. Inv. 500-11.

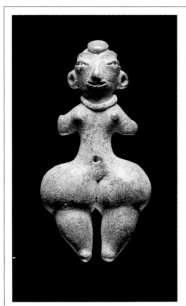 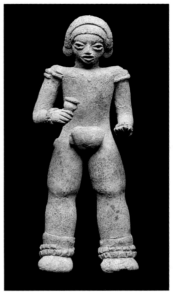

The Early 'Preclassic' Period in Mexico

From the middle of the 2nd millennium BC until just before the birth of Christ, Mesoamerica went through a so-called 'formative' or 'preclassic' period. This was subdivided into three stages: early, middle and late. The site of San Lorenzo belonged to the first, having been organised and developed between approximately the 13th century and the 10th century BC. La Venta was founded in about the year 1000 and ended about 400 BC in the 'middle formative' period.

In Tlatilco, and other sites in the Altiplano, the Olmecs' presence is indicated by the 'hollow round-faced babies' (Fig.19) made in Olmec style but modelled in local clay during the so-called Ayotla phase of the early 'preclassic' period (1200–1000 BC). The figurines (Fig. 17: above left) commonly known as the 'Pretty Ladies' were produced by local workshops and have been dated by recent research, as coming from the following, so-called Manantial phase (1000–800 BC).

Finally we can mention a style peculiar to the early 'preclassic' period, the 'Xochipala' style, named after a village in the centre of the state of Guerrero. Although contemporaneous with the beginnings of the Olmec expansion (1200–800 BC), its art bears no particular resemblance to the art of the 'metropolitan' region, be it in its terracotta statuettes (Fig. 17: above right), or in its stone bowls decorated with a bas-relief of stylised animals, two examples of which are on exhibition in the Museu Barbier-Mueller in Barcelona. However, numerous Olmec-style objects and monuments have been found in the Xochipala area and the rest of Guerrero as well as engravings or wall paintings in cave-sanctuaries (see chap. IV).

The idea that Guerrero was only peopled by small groups superficially influenced by the Olmec civilisation, or who imported some Olmec objects, ought to be abandoned since the discovery of an actual site in Teopantecuanitlán, in the Upper Balsas. Stone monuments decorated with Olmec motifs formed part of elaborate architectural structures. This discovery provides powerful arguments to those who have an image of a pan-Olmec Mesoamerica, where groups from diverse backgrounds and with different languages would have shared some forms of socio-political organisation and some beliefs.

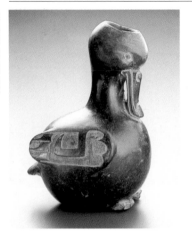

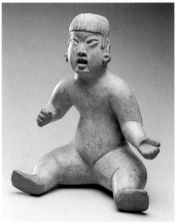

Fig. 18
Several sites in the Mexican Altiplano have revealed artefacts in typically Olmec style, imported or created on the spot within the colonies of Olmec merchants, such as this pottery duck-shaped vase. It is assumed that their prototypes existed in the 'metropolitan' region and were victims of the climate. Las Bocas (?). About 1000 BC. Height: 23.7 cm. Inv. 501-10.

assess the unity of style found both in the sites of the 'Heartland' and those of the Altiplano. Here certain Olmec themes frequently recur on ceramic artefacts (Tlapacoya, Tlatilco, Las Bocas) or in large rock engravings (Chalcatzingo).

The Olmec Religion

There is no doubt that sculptors and engravers or lapidaries worked exclusively for an aristocracy who held a God-given power and who were responsible for carrying out certain rites (agricultural in particular) on which the survival of the community depended. We also have reason to believe that the ritual game of playing with a rubber ball already existed. It is possible that at some previous ancient time, the winners of the holy game were believed to have been elected by heaven. One of the most renowned experts on the Olmecs even went as far as to say: 'I believe that all pelota players were politicians!'

Fig. 19
Hollow baby-faced ceramic figure. This would have been found in the state of Guerrero. Most of the pieces of this type come from the Altiplano (Tlatilco, Tlapacoya, Las Bocas, etc.). Early 'preclassic' period. 1200–800 BC. Height: 30.4 cm. Inv. 501-11.

Did the Olmecs believe that they were the product of a sexual liaison between a woman and a jaguar? It is easy to assume this, judging from some mutilated statues from the 'metropolitan' zone showing a large feline astride a person of undefined sex. The theme of the 'chuppy-cheeked person' (Fig. 19), with a drooping mouth and sometimes with the addition of protruding fangs, is found everywhere that the Olmec influence is felt. Many specialists believe that these effigies represent the transformation of a shaman into a jaguar, a phenomenon which has been widely observed in various groups of present-day native Americans.

This hollow female pottery figure with polychrome decoration is without a doubt the largest to have been recorded. It comes from an unidentified protoclassic site in Guanajuato. The decoration 'in X' is typical. Probable date: 600–100 BC. Height: 71 cm. Inv. 500-20.

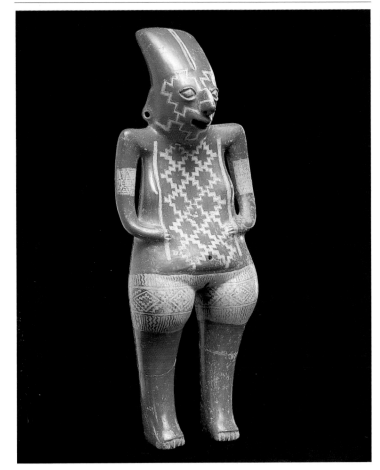

The End of the 'Preclassic Era'

At the end of the 'preclassic' era, i.e. the last centuries BC, the site of Chupícuaro produced some very individual-looking figurines. The technology of these hollow figures may have derived from the Olmecs, but these later North-Western figures, from Guanajuato and Queretaro, achieve their own unique style, some reaching a height of 70 cm (Fig. 20). By this stage Chupícuaro was outside the Olmec sphere of influence but still continued the tradition of depicting pre-classic humans (as in the example of the 'Pretty Ladies' of Tlatilco: Fig. 17, left). The site of Chupícuaro is now buried under a dam. It is assumed that these figurines indicate some sort of union between the High Plateau and the North-West. Their funerary art, charac-terised by ceramics of all sizes, will be the subject of the next chapter.

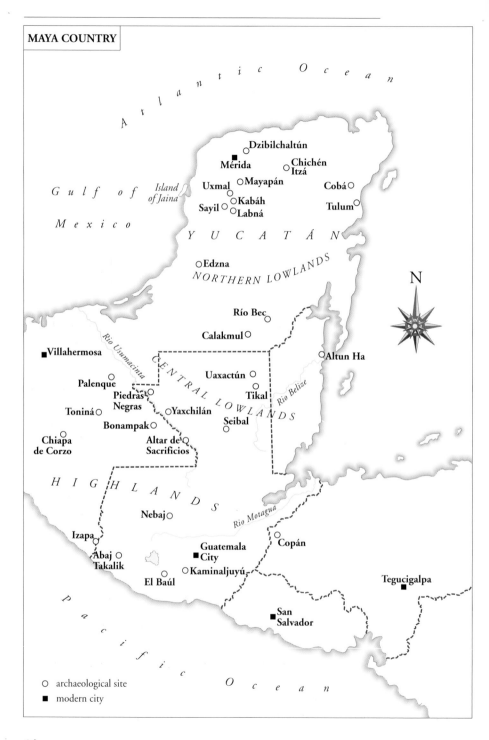

MAYA COUNTRY

Atlantic Ocean

Gulf of Mexico

Island of Jaina

○ Dzibilchaltún
■ Mérida
○ Chichén Itzá
○ Mayapán
Uxmal ○
○ Cobá
Sayil ○ ○ Kabáh
○ Labná
Tulum ○

Y U C A T Á N

○ Edzna

NORTHERN LOWLANDS

N

○ Río Bec
Calakmul ○

■ Villahermosa

Río Usumacinta

○ Altun Ha

CENTRAL LOWLANDS

○ Uaxactún
Palenque ○
Piedras Negras ○
Tikal ○
Río Belize
Toniná ○
○ Yaxchilán
Seibal ○
Bonampak ○
Chiapa de Corzo ○
Altar de Sacrificios ○

H I G H L A N D S

Nebaj ○

Río Motagua

Izapa ○
Abaj Takalik ○
Guatemala ■ City
○ Copán
○ Kaminaljuyú
El Baúl ○
Tegucigalpa ■

■ San Salvador

Pacific Ocean

○ archaeological site
■ modern city

III. The Mayas

We have long wondered about the origins of the inspired people who demonstrated such creative genius, taste and technical know-how that it places their civilisation on a level with those in ancient Egypt or Greece. It is hard to believe that modest maize farmers could nurture such ambitions that they would choose to leave their huts and erect such elaborate buildings, invent a writing system, and develop extensive knowledge of mathematics and astronomy. They thus passed from the most primitive stage to the incredibly sophisticated civilisation which we have learned about from documents saved by Spanish missionaries, from manuscripts (four in total), inscriptions on stelae, and ceramics, and finally from the ruined palaces in cities which had already been abandoned for centuries by the time the Europeans arrived.

Nevertheless, we need only look at the evidence: it suggests (in Belize for example) that ancestors of the Mayas lived for millennia in the vast region where the great 'classic' period flourished. This was an area which would influence the inhabitants of El Salvador and Honduras, as well as Nicaragua further south.

From the Olmecs to the Mayas in the 'Classic' Period

When the Olmec civilisation was at its peak on the borders of the gulf of Mexico, in the watershed year of 1000 BC, it exerted more than a cultural influence over very diverse peoples. This was a colonisation supported by military means; a chance for the Olmecs to set up 'commercial centres' to ensure a continual supply of jade, serpentine, obsidian and other materials unknown in the lowlands where they lived. It is clear however that Mesoamerica had, for sev-

Fig. 21
Map of Mayas.

eral centuries, been under the influence of a pan-Olmec culture shared by groups which were both ethnically and linguistically different. Olmec-style sculptures have been found as far away as the shores of the Pacific in the West, in Honduras and even in Costa Rica in the South. These sculptures are characterised by figures with the mouth of a jaguar, usually drooping at the corners.

As part of this cultural expansion, from the 4th century BC and for several hundred years later, Olmec-style stelae were sculpted over the whole of southern Mexico and southern Guatemala. We can see how they evolved and finally emerged into the great sculptures carved in relief, typical of the classic Maya period, which began in the 3rd century AD.

This intermediary period, of which we still have only a vague pic-

A Brief Chronology of the Mayas

2400 BC
Villages with platforms (on which wooden temples were built) are found in the Lowlands. After 2,000 years of use, the platform gave way to a pyramid (Cuello in Belize for example).

900 BC
In Copán, a tomb covered by a classic monument contains vases decorated with motifs which are pure Olmec.

300 BC–AD 150
Pre-Maya cultures exist in the central and northern region, including the Chicanel (300 BC–AD 150). These are contemporaries of the 'protoclassic' Miraflores culture, found in Kaminaljuyú, in the Highlands, in the South. First stone temples. The Maya vault appears about AD 200. Stelae are only being sculpted in the Highlands. The Highlands would not, however, witness the same architectural development as in the Lowlands, where huge numbers of stelae would be built.

300 AD
First stela in the Lowlands, in Tikal, dated AD 292. 'Classic' period.

400 AD
The Highlands and Tikal are under the domination or the strong influence of Teotihuacán. Beginnings of polychrome pottery, stucco decoration and frescoes.

475 AD
First dated stela in Yucatán.

600 AD
Teotihuacán falls. 'Middle classic' period. No more construction, or erection of stelae, for several decades.

642 AD
Construction of the Temple of the Sun in Palenque. Beginning of the 'late classic' period. Renaissance of Tikal. Monuments spring up on many sites in the centre and the north.

900 AD
The cities in the centre are abandoned one after the other. Last stela in Tikal in AD 889. Start of the 'postclassic' era.

987 AD
The legendary Toltec king Quetzalcóatl ('Kukulcán' in Maya) arrives in Yucatán. His Itzas seize Chichén Itzá. Start of the Toltec-Maya style.

1000 AD
The Xiu dynasty takes power in Uxmal.

1200 AD
The Itzás are hounded out. The city of Mayapán rules Yucatán.

1460 AD
Yucatán is divided into sixteen small principalities. Architecture and art have deteriorated.

1517 AD
Hernandez de Cordoba discovers Yucatán.

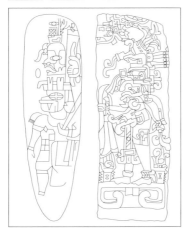

Fig. 22
Left, an Olmec axe engraved with the effigy of a deity (8th–5th century BC). The same deity, transformed, inspired the image found on a stela in Kaminaljuyú (1st century BC), right. The long nose of the god was retained in the depictions of the Maya Rain God, Chac.

Fig. 23
Cone-shaped goblet in antigorite, still full of cinnabare. Izapa style. End of 1st millennium BC. Height: 8.8 cm. Inv. 502-22-A.

ture, lasted from the end of the Olmecs until the beginning of the Mayas, falling within the period known sometimes as the 'recent preclassic' or 'protoclassic'. It was at this time that the major 'civilisation of Izapa' emerged, named after an archaeological site on which pyramids made of brickwork and large boulders were discovered. Fifty stelae, with no inscriptions, were also found here and have been dated between the 4th century BC and the 2nd century AD. Other monuments in identical style (Fig. 23), contemporaries of the ones just described, have been found in Abaj Takalik and El Baul in Guatemala, in a region parallel to the Pacific Coast, extending as far as Kaminaljuyú (see map, Fig. 21).

There is also evidence of the Izapa civilisation, which we hesitate to call Olmeca-Maya, in the Chiapas (in Chiapas de Corzo) and on the site of the ancient Olmec cities of the Gulf (La Venta and Tres Zapotes).

By comparing two images (Fig. 22) separated by half a millennium, we can see the changing image of the Olmec Jaguar-God, transformed firstly into a figure with a long nose and bloated lips in Kaminaljuyú, and ending eventually in a fantastic portrait of Chac, the Maya Rain God. Chac's monstrous face adorns the façades of the dead cities of Yucatán, and his mask covers the face of people portrayed in a standing position and in profile on a number of classic Maya stelae or reliefs.

What religious ideas or myths did these motifs convey? By careful study of archaeological material belonging to the Mayanists, it has been possible to outline some theories. These are, however, too complex to set out in a brief commentary.

Maya Political Organisation and Architecture

The classic Maya era began in the 3rd century AD. It would end about the year 900, after which the 'postclassic' period began (see box listing brief chronology on page 36) and lasted until the arrival of the Spanish. Its cultural beginnings were nurtured by the relations fostered between the 'protoclassic' principalities of the Highlands (200 BC–AD 300), particularly Kaminaljuyú (today a suburb of Guatemala City) and the Maya villages of 'lowlands', the central region. The latter were called on to transform themselves very rapidly into powerful cities, like Tikal.

For the classic period as a whole, it is more appropriate to compare the Maya city-states with those of Mesopotamia during its neo-Sumerian period, than with those of ancient Greece, for the reason that democracy was completely unknown in the Maya states.

The princes, deified after death, had considerable religious powers. The Mayas' intellectual efforts were strictly dependent on their beliefs. Astronomy, hieroglyphics, measuring time: everything revolved around religion, which was itself centred on the personality of the sovereigns and the reigning dynasties.

The masses of peasants and artisans, not to mention slaves, toiled throughout the year for the greater glory of their princes. The gods who protected these princes demanded even more attention: this included paying their dues in the unpaid labour (corvée) needed to build the temples and palaces and erect the monuments that we admire today. It is possible that it was this obsession with grandeur which led to the end of these holy cities. It has been suggested (a romantic hypothesis) that the lower classes, exploited by their monarchs, rose up against them, massacred them and then let the great forest take over the finely sculpted temples and altars.

The platforms and pyramids were built according to a simple design, surrounding a rectangular courtyard on three or four sides. Starting from this basic idea, the Maya town-planners designed huge cities, both in the central region and, later, in the northern region of Yucatán. It has been estimated that, in its glory years, 40,000 inhabitants were crammed into Tikal, whose first stela is dated at AD 292 (one of the oldest truly Maya monument). As for Copán in Honduras, this city stretched over an area of nearly 300,000 sq. m.

When the cities expanded, pushing domestic dwellings further and further from the centre, the new ceremonial buildings were built in harmony with one another, always preserving vistas. They preferred a symmetrical layout, rather than lining up large buildings along a

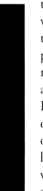

single avenue which simply extended the original small courtyard. The famous truncated pyramids were in fact bases for temples, constructed firstly in light materials and modelled on the huts in which the people lived, then built in stone and decorated in local style. Access was via one or several staircases.

The pyramids were sometimes used as tombs, another reminder of Egypt. The last residence of a powerful monarch who reigned from AD 615–683 was found in Palenque in 1952 in the heart of the so-called 'Temple of the Inscriptions'. The deceased man was laid to rest under a superbly sculpted tombstone, showing him half bent over and in the process of dying. He was surrounded by jade jewels and a mask made of small pieces of jade.

There were also several palaces among the stone buildings outside the pyramids. It has long been believed that these were meeting places for priests. Indeed, it appears that the priests, along with members of the prince's family, lived in such palaces at least during religious festivals and when participating in cult activities.

In all these edifices the observer is struck by the original ideas: the existence of doors and corridors or chambers with a corbelled arched ceiling. This latter was a remarkable creation which appeared very early, before the beginning of the actual 'classic' era, about AD 150.

Maya Art

To think of Maya art conjures up images of façades of temples decorated with bas-reliefs, stelae commemorating illustrious kings, or miniature masterpieces made by lapidaries. The Mayas had inherited the Olmecs' immoderate taste for jewellery and other small hard stone artefacts. (Fig. 24). These same lapidaries created funerary masks made of pieces of jade and assembled, like a jigsaw puzzle, on a mould adapted to fit a particular face. More rarely, these were made of one single piece, like the famous green fuchsite mask from the Wray collection of antiquities, now in the Museu Barbier-Mueller (Fig. 25).

Any museum of pre-Columbian art should assign a special place to the creations of the potters, notably their vases decorated with exquisite polychrome paintings (Fig. 26). Some were stuccoed before being painted and others were engraved,

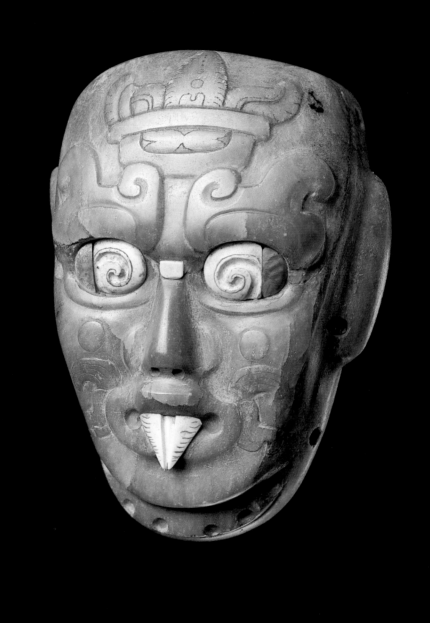

Fig. 25
Funerary mask, with shell inlay, in the image of a god, sculpted in a single piece of fuchsite and with an inscription in hieroglyphics on the inside. Central region. About AD 400. Height: 19.8 cm. Inv. 502-28.

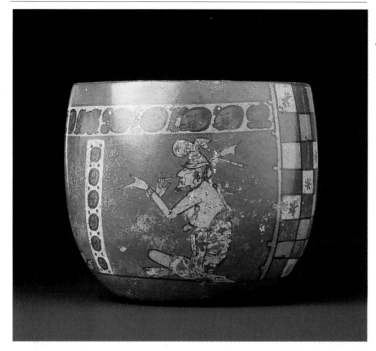

Fig. 26
Bowl from the late 'classic' era, depicting two people, a man and a woman, facing each other (here only the man is visible). A line of hieroglyphs forms a band near the upper edge, decribing the type of vessel, and possibly the name of its owner. Central region. AD 550–900. Height: 14.5 cm. Inv. 502-23.

either before or after firing, to make the main motif stand out. After the fall of the cities in the central region, when stelae bearing the effigy of the monarchs were attacked with hammers but images of the gods were spared (indicating a popular revolt), and the occupation of Chichén Itzá (we will leave to one side the Toltec-Maya art), the leaders of the bellicose Mayapán dynasty neglected the plastic arts and failed to continue architectural traditions. By AD 1200, the decline of Yucatán was complete.

Maya Writing

Stelae, wooden and stone lintels and decorated vases and cups have all been found decorated with small rounded drawings. These are hieroglyphs, which make up a writing system that can be compared to that of ancient Egypt (Fig. 27). This writing may have been prefigured by the Olmec, but the Maya perfected it.

Without wanting to dwell on the Mayas' intellectual capacities (their mathematician-astrologists invented the concept of zero before the Europeans!) we should nevertheless remember that they invented several calendars. Two of these were the holy 260-day lunar calendar (*tzolkin*) and the 365-day solar calendar, known as the Vague Cal-

41

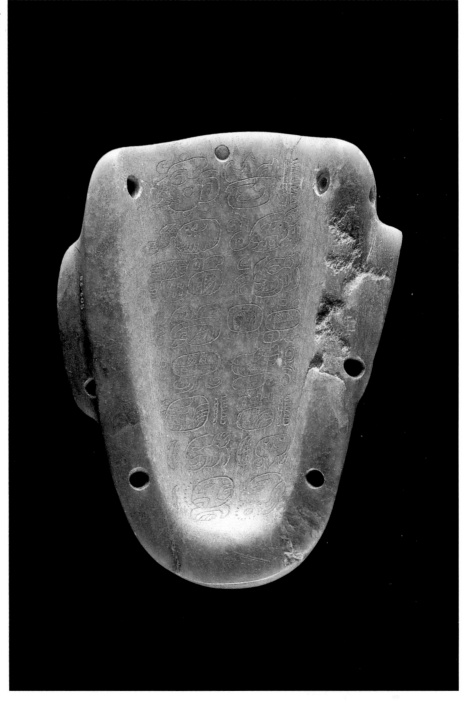

Fig. 27
Inside of the fuchsite
mask shown in Fig.
25, with hieroglyphic
inscription.

endar (*haab*). This latter was divided into 18 months of 20 days plus an extra month of 5 days. The two coexisted and overlapped in a 52-year cycle, known as the Calendar Round, a system which was also used by several other Mesoamerican societies. As each day of each calendar was twinned with one day in the other, the two days only coincided after 52 years of 365 days, or 73 cycles of 260 days! Monuments have been dated by using a third 360-day calendar (*tun*) consisting of 18 months of 20 days and known as the 'Long Count'. We can read these dates by relating it to our calendar, the correspondence between the two having been recorded by Spanish historians in the 16th century. We know therefore that the 'Long Count' dates back to 3114 BC, but we do not know what event this date commemorates. The creation of the world perhaps?

The earliest dates we have found are on monuments outside the Maya region, but which seem to use the 'Long Count'. Again, we ought perhaps to make absolutely certain that the regional cultures which created these inscriptions did not start counting from another date. Nevertheless, it is worth mentioning stela 2 in Chiapa de Corzo in the Chiapas (36 BC), stela C in Tres Zapotes (31 BC) and stela I in El Baul, Guatemala (AD 36).

Great advances have been made in decoding Maya hieroglyphs in recent years. Many of the names of kings, queens and generals are now known. We even have the signatures of sculptors and painters (one of whom was a prince of royal blood — long before European royalty could read or write!). We are now able to piece together history as recorded by ruling dynasties.

The End of a Civilisation

When one of Cortéz's lieutenants, Francisco de Montejo, launched the assault on Yucatán, he found himself facing nothing more than the remains of principalities. Nevertheless, his life was still made difficult by the natives' fierce guerrilla tactics.

The Europeans would eventually win. The locals were not disturbed in Tulum, however, nor on the Caribbean Sea, and held out even longer in Tayasal (the present-day Flores, where the Itzá people's nomadic days finally came to an end) and in the isolated hills of the Chiapas. Maya priests continued to recite their litanies here for several centuries. Even today, in certain places, witch-doctors pray to the god Chac during periods of drought. The writing was lost for centuries, along with the traditions which made the Maya people great.

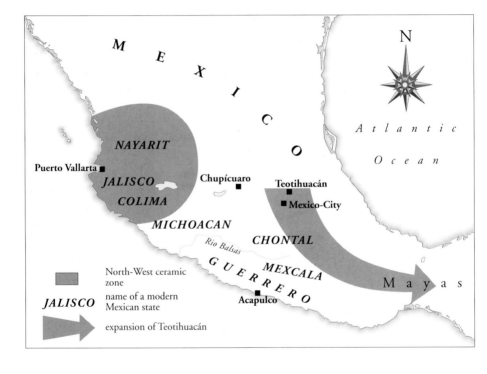

IV. Arts of Western Mexico

Two regions with distinct styles are of interest here. The first is in the heart of the state of Guerrero, north of Acapulco. We do not know who inhabited the area in the 'preclassic' period. At the time of the Spaniards' arrival, they spoke a dialect nahuatl. The second region we will look at is that containing the three states of Colima, Jalisco and Nayarit, famous for their large ceramic statuettes, which were hollow and funerary in style (Fig. 28).

The Mezcala and Chontal Styles of Guerrero

Since the 'early preclassic' period (about 1300 BC), the inhabitants of the state of Guerrero had been in constant contact with Olmec merchants who came to stock up with the hard stones needed for making jewellery, figurines and masks for magical or religious functions.

A number of artefacts made in typical Olmec style have been discovered in the Guerrero, a hilly, arid region crossed east to west by the Rio Balsas. These artefacts were probably manufactured in the area, with two aims in mind.

They would either be exported to the gulf of Mexico and, beforehand, to the Altiplano, where colonies of Olmec merchants had settled in Chalcatzingo, Las Bocas or Tlatilco (see chapter II); or they would be partially used on the spot, if Olmec colonies or trading posts had been set up there, or if the indigenous people had been converted to the Olmec religion.

To the north of the Rio Balsas, apart from the artefacts in possible Olmec style, lapidaries produced stone masks called 'Chontal' (named after a small tribe recognised by the Spanish in the 16th cen-

Fig. 28
Map of Western
Mexico.

45

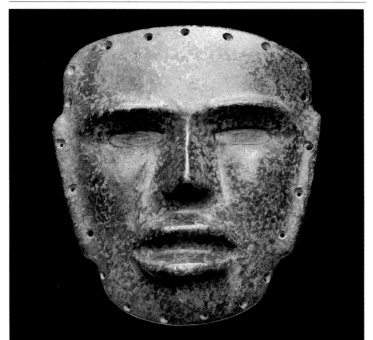

Fig. 29
Stone mask, Chontal style, with numerous holes for fixing it (for placing on the face of a dead body, on top of the bundle of material covering the corpse?). Guerrero. Between 100 BC and AD 300? Height: 14.4 cm. Inv. 503-9.

tury). They are fairly naturalist in style and do not reveal such obvious traces of Olmec influence (Fig. 29). To the south of the Balsas, the 'Mezcala' style dominates and has passed down to us numerous anthropomorphic statues in hard stone (Fig. 32). Their geometric shapes, reminiscent of the art of the Cyclades, has made them famous among collectors. Most of these figures depict an image of a person face-on, their flat body cut with grooves to represent their arms and legs. Images of animals are much rarer, which is why we have chosen to reproduce one of these here (Fig. 30).

A stone 'mask' shows both the characteristics of the 'Mezcala' style, and a clear Olmec influence, in its drooping mouth (Fig. 31). (We do not of course know what all these artefacts were used for.)

The dating of these beautiful examples of the Guerrero lapidaries' art has provoked controversy, following the discovery of 'Mezcala figures' in offertory caches in the Templo Mayor in Mexico. It has been suggested that the figurines could have been contemporaneous with the Aztecs but there is no reason to update them to their time. The Aztecs admired and respected relics from the past and, like their predecessors, they probably believed that objects found in built-up sites were invested with a sacred value. Stone masks from Teotihuacán

Fig. 30
Figurine in antigorite,
depicting a monkey,
created by string
cuts, using quartz
powder. Style of
Mezcala. Guerrero.
End of 1st millennium
BC. Height: 5 cm.
Inv. 505-9.

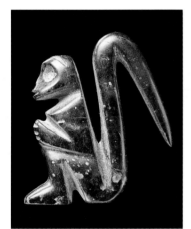

have also been found in the Templo Mayor and so has an Olmec mask! It is obvious however, that only extensive archaeological digs on several sites could tell us about the people who produced these works which were found by chance or by some casual foraging by peasants in their neighbourhood. It does not seem unreasonable, however, to place them in the 'late preclassic' and 'protoclassic' period (4th century BC–2nd century AD) or possibly, for the last ones to be made, in the 'early classic' period.

— The Anthropomorphic Pottery of the North-West

Unlike the Tarascans of the Michoacán (see map Fig. 28), the inhabitants of the North-West (Jalisco, Colima, Nayarit), spoke the nahua languages. However, the large ceramic statuettes discovered in these three states by local excavators were erroneously described as 'Tarascan art' when they made their entrance into the world of collectors and museums.

The tradition of making anthropomorphic terracotta figures dates back to the beginning of the 'preclassic' period, in the Highlands. As well as the so-called 'Pretty Ladies' figurines (Fig. 17: left) larger effigies of women have been found in Tlatilco. These are in the same style as the gracious little women with their slanting eyes and generous figures. There are even wonderful figures of acrobats, with one foot on their head... An abundance of Chupícuaro figurines were produced in the 'preclassic' period to the north of the capital and some very large statuettes placed in tombs (Fig. 20).

Again, we know very little about the ceramics of the North-West, almost all of which were found during non-scientific excavations over the last fifty years. At least we know the specific form of the tombs in which were sometimes placed as many as ten or twelve figures (Fig. 33). Such tombs were a type of burial place unique in Mesoamerica, but found in the Andes. A deep vertical shaft provided access to one or two underground chambers hollowed out in the rock, where the remains of several individuals were deposited. Recent research has established that these figures date from the 'late preclassic' (or 'protoclassic' period, which has been confirmed by an analysis of the clay using thermoluminescence. This does not rule out the possibility that some were still made in the first centuries of

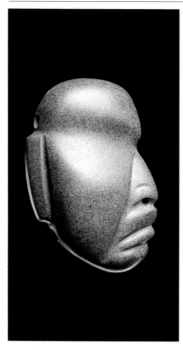

Fig. 31
Mask (pendant) in serpentine. Style of Mezcala, with Olmec influence. Guerrero. Second half of the 1st millennium BC. Height: 12.8 cm. Inv. 505-26.

Fig. 32
Stone figure. Style of Mezcala. Guerrero. Second half of the 1st millennium BC. Height: 26.6 cm. Inv. 505-14.

the 'classic' era in the 4th and 5th centuries AD) and that they were used specifically for funerary purposes. It is not possible here to examine the stylistic peculiarities of pieces from Colima, Nayarit or Jalisco. The former are more inclined to naturalism than the latter, whose bodies are modelled more freely.

What is remarkable about the art of the potters of the West Coast, is the expression given to the characters depicted, some of which display the most true-to-life positions, as if the artist had wanted to create a natural 'live-action' sketch of his subjects.

To return to the very specific form of the shaft and chamber tombs, it has been suggested that the South Americans could have made it this far up the coast of Mesoamerica. Technically this is not impossible: on a reconnaissance voyage off the Ecuadorian coast, Pizarro's men came across a solid balsa-wood raft, transporting precious artefacts that the adventurers hastened to confiscate.

Fig. 33
Large female funeral figure entirely in ceramic, with polychrome decoration. Nayarit style. Region of North-West Mexico. First half of the 1st millennium AD. Height: 61 cm. Inv. 504-2. Former John Huston collection.

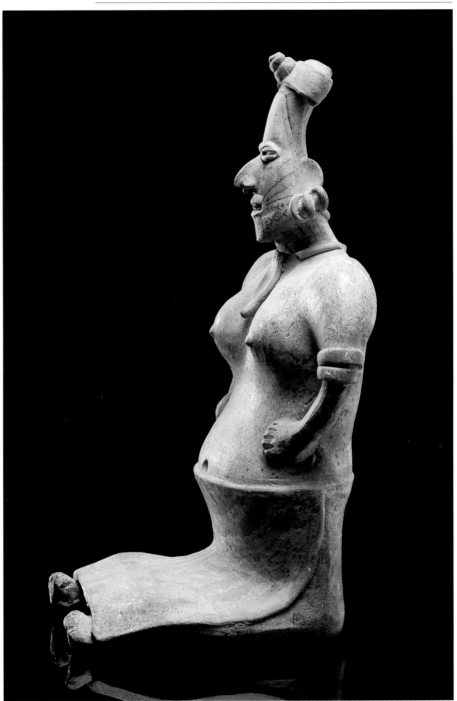

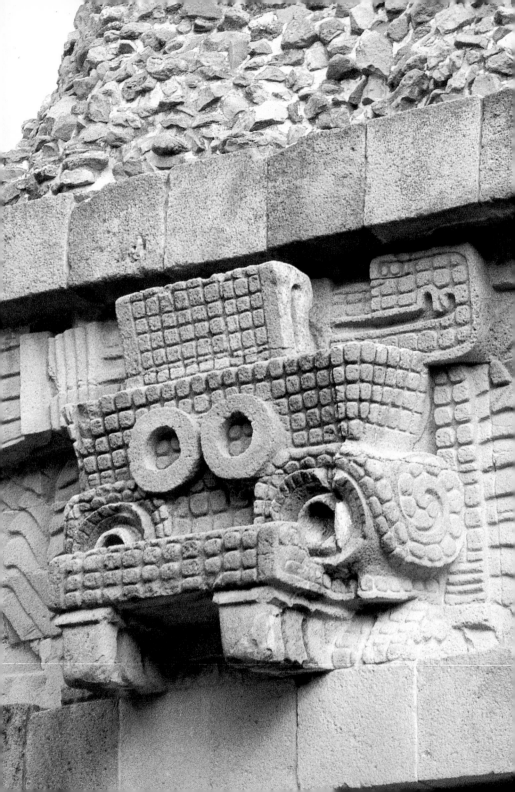

V. Three Cities from the Classic Era: Teotihuacán, Monte Albán and El Tajín

Teotihuacán is undoubtedly the most prestigious of these three cities: an endless field of ruins, crowned by two huge pyramids, only an hour's drive from the capital, Mexico City. Monte Albán, in the heart of the country and now home to the descendants of its founders, the Zapotec Indians, in the state of Oaxaca, has more ancient origins, as proved by the discovery of stelae (Fig. 39) engraved with people resembling Olmecs. (Its grandeur however dates back well into the 'classic' period which takes up the last three-quarters of the 1st millennium AD.) Last but not least is El Tajín, hidden in the thick forest in the State of Veracruz, today revered by the Totonac Indians. It deserves an equal stature with its peers: one of its holy buildings, the Temple of the Niches, is unique of its kind, it alone a testimony to the heights of inspiration of the Mesoamerican architects, and of their limitless ambitions.

Teotihuacán

The Aztecs, who had arrived on the Mexican central plateau almost half a millennium after the collapse of the huge city, believed that no human being could have built such huge buildings. They gave it the name by which we know it, and which means (according to a recent hypothesis): 'The Place of The Ones Who Have the Avenue of the Gods'. It was here that they located the central event in their mythology, believing that the sun and the moon had been created in Teotihuacán (see maps Fig. 14 and Fig. 28).

The visitor today is as impressed as the Aztecs were by the immense Avenue of the Dead which starts at the foot of the Pyramid of the Moon, runs alongside the Pyramid of the Sun (Fig. 35) and reaches,

Fig. 34
Detail of the temple called
'of Quetzalcóatl'
in Teotihuacán.
The head is that of the 'Rain God'.
Photo Jean Paul Barbier.

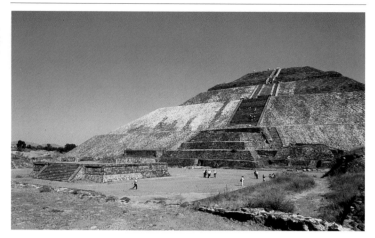

Fig. 35
View from the
Pyramid of the Sun,
seen from the
Avenue of the Dead.
There used to be a
temple at its summit.
Teotihuacán.
1st century AD.
Photo Jean Paul
Barbier.

two kilometres further on, the third architectural complex, the so-called 'Ciudadela'. Here an edifice from the 4th century AD overshadows the facade (Fig. 36) of the so-called Temple 'of Quetzalcóatl', which is decorated with the protruding heads of serpents with collars of feathers, alternating with masks with tubular eyes representing the Storm God (or Rain God). All around are the remains of two thousand houses, compounds where several apartments were separated by patios, and linked by corridors.

In the 2nd century BC, Teotihuacán began to benefit from the decline of the main cities in the nearby valley of Mexico, and in particular of Cuicuilco. Although its lesser rainfall made it less fertile than its neighbour, the valley of Teotihuacán occupied a strategic commercial position. Seams of obsidian also made up a large part of its fortune.

Nothing at all is known about the ethnic origins nor the language of the founders of this city which, in the pre-Hispanic era, was to become the largest metropolis on the American continent and, indeed, the world, and the first to be laid out in a grid pattern. It is probable that in the centuries which saw the construction of the famous pyramids, followed by the building-up around them of so many workshops and houses, the riches of the city attracted a number of foreigners. Examples of this are a district which was founded by people originating from Oaxaca, and another inhabited by merchants from Veracruz and their families. It is not known however who had political power.

The two Pyramids were completed at the end of the 1st century AD or the beginning of the 2nd century AD. The so-called 'Pyramid of

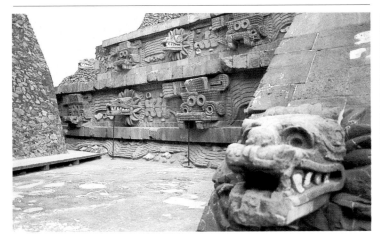

Fig. 36
Façade of the temple of Quetzalcóatl, the 'Feathered Serpent', buried in the 4th century AD under an adjacent building, which has been uncovered in modern times. Teotihuacán. 2nd century AD. Photo Jean-Louis Sosna.

the Sun' was erected in one continuous operation, unlike other monuments of the same type elsewhere in Mexico, which were gradually added to, each new structure covering the old. Recent excavations have uncovered a long cave under the Pyramid of the Sun, the presence of which justified the choice of site, as natural caverns were supposed to be places for communicating with the gods.

Whether or not this is the case, recent excavations under the Temple of the Feathered Serpent have revealed that over two hundred individuals, most of them warriors, had been killed, their hands tied behind their backs, at the time the building was consecrated. Comparison with similar sacrifices, in Monte Albán or the Lowlands of the Maya country, appear to indicate the presence of a military power in the region.

The Expansion of Teotihuacán

The territory controlled by the main city did not extend much beyond the valley where it was built. Nevertheless, some features peculiar to the Teotihuacán civilisation have been found a long way from their source. One element in particular is the characteristic *talud-tablero* feature of holy buildings which are embellished with superimposed sloping aprons or 'talus' and vertical 'panels' (*tablero*). Also typical are the cylindrical tripod clay vases, regular features of Maya art. Eight *tableros* were added on to a pyramid in the famous Maya kingdom of Tikal during the second half of the 3rd century AD. This period also saw a prince of Teotihuacán origin come to power in other Maya cities, such as Uaxactun. In AD 378, a monarch known as 'Curl Nose' was crowned in Tikal. If he was not

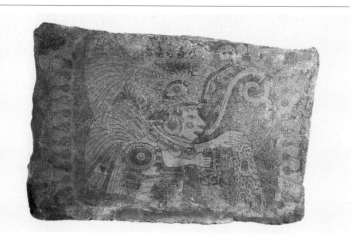

Fig. 37
Fragment of a stucco painting depicting a high-ranking official, identifiable by his structured hairstyle in the act of libation. The spiral coming out of his mouth represents the sacred song that he was singing. Teotihuacán. 4th and 5th centuries AD. Length: 101 cm. Inv. 506-1.

originally from Teotihuacán, he was at least depicted on stelae, dressed as a warrior from the far-off city.

The technique of painting stuccoes, used by the Mayas for certain particularly fine ceramics, is probably also of Teotihuacán origin, as is the obsidian that has been found as far afield as Guatemala, where *talud-tableros* have been found on the façades of temples in Kaminaljuyú. Experts have asked whether regions so far apart could have been the object of genuine military expeditions, or if the traders sent to sell Teotihuacán's products and to acquire certain commodities found in the tropical zone, brought priests with them who converted the elite of Maya Highlands society to their religion. There is no clear answer to this question. It should be added that, despite the contact indicated by the reliefs in Monte Albán and an 'Oaxaca district' in Teotihuacán, the former does not use the *talud-tablero* feature in its architectural structures.

Teotihuacán Art

We might expect that the people who decorated their city's main temple so magnificently (Fig. 36) would have erected a fair amount of monumental stone sculptures. We have in fact counted three, none of which is very elaborate. The lapidaries mainly created stone statuettes, the largest of which were made of volcanic stone, and the smallest of beautifully-coloured minerals (but almost never jade). Most significantly, they produced masks made with unusual sensitivity (Fig. 39). It is not known what these were used for: they have holes for fixing them somewhere, but their weight makes it unlikely that they would have been worn by a participant in a ceremony. It

Fig. 38
Anthropomorphic
urn, depicting a
person sitting. Some
features, such as the
ear-rings, are a sign
of the influence that
Teotihuacán
exercised over
Monte Albán, from
the 4th century AD.
About AD 500–700.
Height: 51.8 cm.
Inv. 503-11.

Fig. 39
Mask made of
serpentine, whose
eye cavities and
mouth used to be
decorated with inlays
symbolising the teeth
and the eyes.
Teotihuacán.
4th–5th centuries AD.
Height: 13.5 cm.
Inv. 506-2.

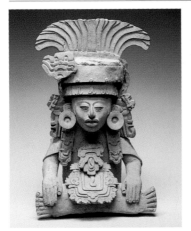

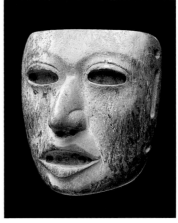

has been suggested that they may have been placed on the material covering a corpse, in Peruvian style, but this is only conjecture.

The Aztecs were impressed with the beauty of these masks and similar objects have been found, well-preserved complete with inlay, in some of their holy places.

The ceramists have bequeathed us some beautiful thin-walled, orange-coloured pottery (which was exported far and wide) and large incense or copal burners, made from several pieces.

Finally, we have the frescoes (Fig. 37), made predominantly of mineral colours, that have been found in some of the houses excavated in this century. These are the most striking evidence that we have of the splendour of Teotihuacán. Bearing in mind that the exteriors of all the monuments, temples and pyramids used to be painted, it is easy to understand that the grey stone mounds that we see and admire today, would have greatly upset the inhabitants of Teotihuacán.

Monte Albán

Founded several centuries before Christ and influenced, as the Mayas were, by the Olmec culture, the city whose ruins we see today near Oaxaca, was also an urban centre, laid out around the stone-based temples and along the sides of a rectangular courtyard which seemed to be embedded in the surrounding heights. It never reached the size of Teotihuacán, however, nor did it have the same influence. The central courtyard in question, 300-metres long, was certainly not just used for processions or religious events. Taking into account the numerous houses surrounding the temples and ceremonial

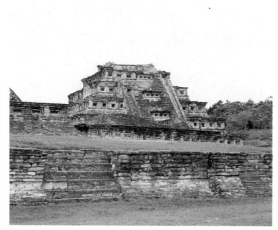

buildings, it is probable that it was used as an agora, a place where traders came to sell their products.

The edifices on top of the platforms had wooden roofs, which, like their adobe-brick walls have disappeared.

There were three types of houses. The largest were undoubtedly reserved for the elite, the nobility; the medium-sized ones belonged to the wealthy, or to those in some public position, and the small ones were for the workers. In all three cases, the rooms look out onto a central patio, built over underground tombs.

Some magnificent jade objects have been found which originate from Monte Albán but it was through its ceramic 'urns' that it really earned its reputation among experts. Their style shows that the potters had moved away from the Olmec-inspired bare realism that had marked the culture's early years. This development parallels that of the Mayas, who produced an even more complex confusion of curvilinear motifs. Contrary to a widespread idea, these anthropomorphic vases (Fig. 38) depicting deities or, more probably, the deceased with the features of a god, were more likely to contain offerings and small artefacts than ashes or bones.

Fig. 40
The Temple of the Niches in El Tajín (Veracruz). Construction on the temple undoubtedly began well before it reached its final glory, about AD 600. Photo Monique Barbier-Mueller.

Fig. 41
Drawing of a bas-relief in El Tajín. A pelota player is put to death by a man using a flint knife. The executioner, his aid and the victim wear broad belts ('yokes' hatched with orange) with palmas (coloured red) attached.

El Tajín

Thirty kilometres from the Atlantic Coast, north of the State of Veracruz, El Tajín looks today like a collection of pyramids and faced stone structures. Among these the 'Temple of the Niches' is one of the earliest (Fig. 40). Its 365 niches may have contained statuettes or other religious artefacts. Numerous bas-reliefs, dating from the late classic period (7th century AD) make reference to the sacred game

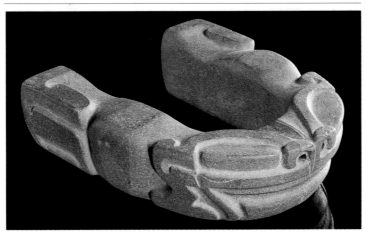

Fig. 42
'Yoke' in archaic
stone, decorated
with the head of the
'Earth Monster'.
The surface of these
artefacts, would later
be covered with
convoluted scrolls,
decapitated heads
and other allusions
to the human
sacrifices which
ended the sacred
game of pelota.
Veracruz.
3rd–5th centuries
AD.
Length: 44 cm.
Inv. 507-19.

of pelota, eleven ball-courts having been laid out on the site. A high-ranking figure is seen here (Fig. 41) plunging his flint knife into the stomach of another man with his hands tied, no doubt the loser of this game, where the ball represented the course of the sun and was invested with a high symbolic value.

The area around El Tajín is today inhabited by the descendants of the Totonacs who welcomed Cortéz in 1591 and provided him with valuable assistance in attacking the Aztec monarch, whose vassals they were. All the (stone) representations of objects used in the ball game have today been classified as Totonac. However, we have no evidence that the coast of the State of Veracruz was peopled by Totonacs throughout the classic period, or that the Pyramid of the Niches was their work (nor do we have proof that they made the first stone *hachas*, *palmas* and *yugos* [yokes], copies of implements which were probably made out of wood). The exact function of these items is the subject of speculation. According to Wilkerson, the only archaeologist to have recently excavated contemporary classic sites in El Tajín, the *palmas* and *hachas*, as the bas-reliefs on the site show (Fig. 41) would have been fixed on broad belts, the so-called 'yokes' (Fig. 42), and were used to hit the ball. The animal's mouth adorning the back of the yokes represents the 'Earth Monster', a mythical creature half jaguar and half toad. It was believed that the ball-game would open the gates to the Underground World, of which the Monster was guardian and the open mouth (which had figured previously on Olmec monuments) the entrance. The *hachas* depicted the severed heads of victims of sacrifices carried out as part of the ball-game. Some authors believe they were used as markers on the

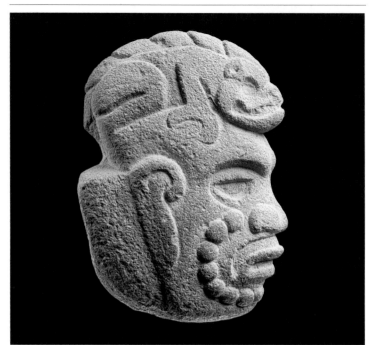

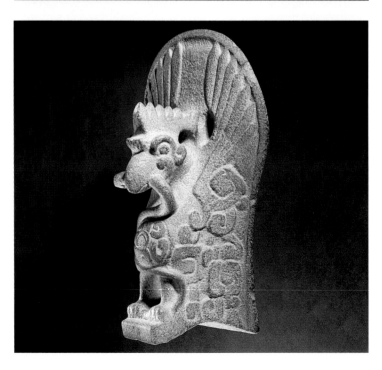

Fig. 43 and 44
Hacha and *palma*
in volcanic stone.
The *palma* is
decorated with
convoluted scrolls,
typical of the 'El
Tajín style'. Veracruz.
About AD 600–900.
Height: 20.9 cm and
31.8 cm respectively.
Inv. 507-9 and 507-10.

Fig. 45
Clay statue
representing
Huehueteotl, the Old
Fire God. Veracruz.
6th–8th centuries AD.
Height: 58 cm.
Inv. 507-18.

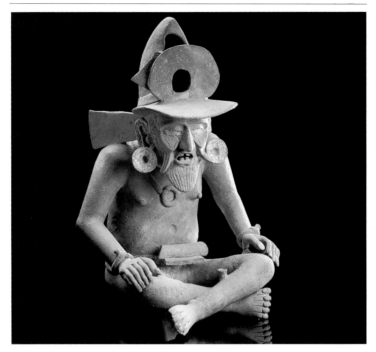

ball-court, either to define the boundaries or to indicate the score. It is not clear what the *palmas* were used for: according to Wilkerson, they were substituted for *hachas* towards the end of the classic era (Fig. 43 and Fig. 44). The *hachas* were adopted by the Mayas in Guatemala and have even been found in El Salvador.

It is equally difficult to identify exactly who produced the large hollow clay statues. The example reproduced here (Fig. 45) bears an extraordinary resemblance to another effigy of the Old Fire God, carrying a brazier on his head, from the Museum of Mexico. It has curiously been dated from the 'preclassic' period, because it was found not far from an Olmec cache but it ought to be reclassified in the 'classic' period. It is probable nevertheless that these hollow statues, together with the smaller ones known as the 'Smilers' could be attributed to the Totonacs. This tradition of large clay statues seems to have endured, as indicated by Bernal Diaz, who accompanied Cortéz when he was received by the 'fat chief' of Cempoala. Diaz described the idols 'as big as cows' which littered the steps of the pyramids, horrified at how keen the Europeans had been to smash them up.

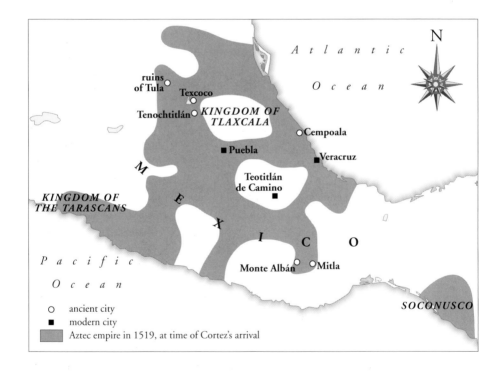

N

Atlantic

Ocean

ruins
of Tula

Texcoco

Tenochtitlán

_KINGDOM OF
TLAXCALA_

Cempoala

■ Puebla

■ Veracruz

M

Teotitlán
de Camino ■

_KINGDOM OF
THE TARASCANS_

E

X

I

C

O

Pacific

Ocean

Monte Albán

Mitla

SOCONUSCO

○ ancient city
■ modern city
▨ Aztec empire in 1519, at time of Cortez's arrival

VI. The Aztecs

The Aztecs were the last arrivals to the Mexican Plateau, after some other Chichimec tribes from the fringes of the present-day Mexico-United States border. Known for their pillaging and warlike behaviour, they found themselves successively driven back by all the leaders of the small towns dotted around Lake Texcoco, which has today disappeared under the urban sprawl of the gigantic Mexico City. Eventually, in 1256, according to the chronicles, they were allowed to settle in the swamps. Their industrious and tenacious character helped them to adapt to their surroundings. They managed to create 'floating gardens' or *chinampas*, by sinking wicker platforms, covered in earth and silt in the shallow water, and thus achieve abundant harvests.

Meanwhile their leaders concentrated on forging a network of alliances, which they denounced opportunely and treacherously when it proved useful. They thus gradually managed to establish their political supremacy over their more numerous neighbours. They needed only one hundred and fifty years, from 1350 to 1500 to make Tenochtitlán (as the village on the lake was named) into a metropolis with a population of several hundred thousand. The city was still based on a lake, but was linked to dry land by sturdy causeways and supplied with drinking water by an aqueduct, as the lake-water was salty.

Fig. 46
Map of the Aztec empire, in 1519, the date of Cortéz's arrival.

Warriors and Tradesmen

Many conquering peoples only accord minor importance to the bravery of their fighters. Although it is true that the Aztec aristocracy was essentially made up of warriors, tradesmen enjoyed consider-

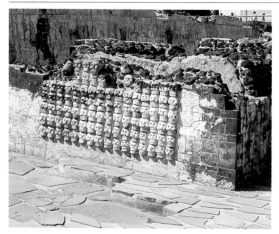

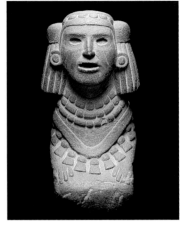

able privileges. The social class of the *pochteca* could more appropriately be called a caste, as it was extremely closed. A member of the masses or *macehualtin* could rise to the rank of a dignitary (*tecuhtli*) by performing brilliantly in battle, whereas only the sons of merchants could succeed to their fathers' highly lucrative positions.

The Aztec monarchs, or *tlatoani* ('the one who speaks'), took seriously the protection of the *pochteca* when they were travelling to far-off countries to collect exotic products. For this reason, garrisons were stationed on the most frequently travelled routes and, although the traders were armed, they were given military escorts when necessary.

The entire history of the Aztecs is made up of a long series of raids launched against neighbouring populations, after which the small cities around the lake were annexed, sometimes under the cover of diplomatic treaties. One such was the Triple Alliance treaty which was signed with the cities of Tlacopán and Texcoco, and was still in force when Cortéz and his men arrived.

Some expeditions resulted in conquests pure and simple, as in the case of the Mixtecs. Others, notably those directed towards the North-West against the Tarascans, ended in bloody failures, although without too much damage to the young empire which had succeeded in securing access to both the Atlantic and Pacific oceans (map Fig. 46). Increasing wealth meant that the expeditions organised by the Aztec kings were no longer undertaken with the sole aim of expanding the national territory. This ambition was in fact quite limited. They were more interested in ensuring they received their payments of tribute, partly in precious objects and partly in human

Fig. 47
Monument (*tzompantli*) of the Templo Mayor of Tenochtitlán showing a collection of skulls. Mexico City. 14th–15th centuries. Photo Jean Paul Barbier.

Fig. 48
Basalt effigy of Chalchihuitlicue, goddess of water and companion to Tlaloc. The name of the deity makes deliberate allusion to the 'collar of green stones' (jade) that she is wearing, and which symbolises water, and therefore fertility. Aztec. 15th century. Height: 41 cm. Inv. 509-3.

beings, who were being sacrificed in increasing numbers (Fig. 47) to assuage the thirst of the deities. The demands of these deities ended up aggravating some of the vassals and this is illustrated by the example of the Totonacs of the present-day Veracruz, whose co-operation with Cortéz allowed the Spaniard to succeed in his incredible enterprise of 1519. Fewer than five hundred Spanish soldiers crossed the mountains and deserts to confront an army of several hundred thousand warriors acting on the orders of a king of divine origin.

A Brilliant and Tottering Civilisation

At the time of the great *tlatoani* Ahuitzotl (1486–1502), the Aztec empire comprised 38 provinces (the list has survived to the present day!) who paid huge tributes in cotton, rare bird feather, cocoa, jade and gold, which the Mixtec artisans based in Tenochtitlán transformed into the finest jewellery.

The Aztecs built huge temples, resembling those they had discovered when they arrived in the Highlands. The sculptors, certainly sensitive to the talent of the artists of Mitla and Veracruz (they were great antique-lovers, specimens having been found in the Templo Mayor in Mexico), also left us a large number of statues. These, we are pleased to note, indicate a return to realism and avoid the embellishments of the 'preclassic' period (Fig. 48 and 49).

The Spanish chroniclers did not hide their astonishment when they came across the suburb of Tlatelolco. The market place was 'twice as large as the city of Salamanca' and the shops were full of strange fruits, jaguar and ocelot furs, people selling animals for meat (especially dogs and turkeys), jewellery, pottery and various other goods. Of course, this was not the Eldorado that Pizarro would find in South America twenty years later, and certainly the crown of quetzal bird feathers which Moctezuma presented to Cortéz (miraculously preserved in the Vienna Museum!) did not please Charles V as much as a few sacks full of gold nuggets. Nevertheless, the Spanish Crown had just been enriched by a magnificent jewel, for the price of the destruction of a civilisation. We might deplore this, but we might also console ourselves by saying that it rested on a balance of forces so fragile and a network of alliances so unstable that it would inevitably have foundered sooner or later, like Teotihuacán and Tula before it.

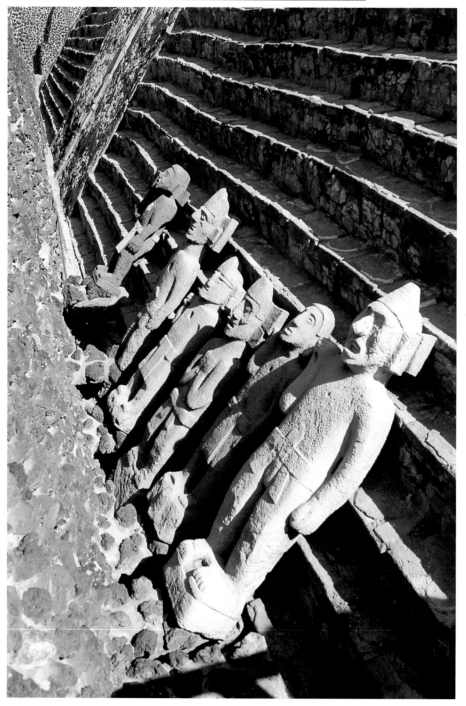

Fig. 49
Series of statues
dating from a period
before the last
enlargement of the
main pyramid in
Templo Mayor in
Tenochtitlán.
An identical statue
is included in the
Barbier-Mueller
collections in
Barcelona.
Mexico City.
Photo Jean Paul
Barbier.

Fig. 50
The anthropomorphic
pillars which
supported the roof
of the wooden
temple at the summit
of the pyramid of
Tula. Toltec.
9th–10th centuries.
Photo Jean Paul
Barbier.

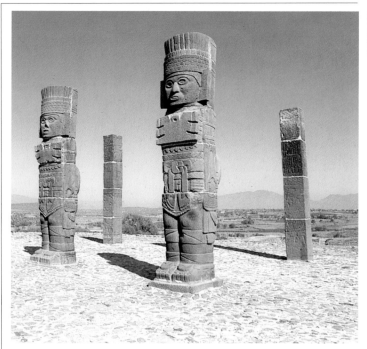

The Toltecs

About AD 750, Teotihuacán, the main city of the Highlands, was destroyed by 'barbarians' from the North. Among these were the Toltecs. They spoke a nahuatl dialect, like the Aztecs after them and made Tula, not far from Teotihuacán, their capital. According to Aztec chronicles, Tula was founded in AD 856, a date which should probably be brought forward a little.

Ten kings succeeded each other until 1168, the year which saw new invasions from the north lead to the collapse of the Toltec civilisation.

These ten monarchs also acted as high-priests. One of them was the subject of a legend adopted by the Aztecs. This character was called Ce Acatl Topiltzin, but he was known by his heavenly nickname: Quetzalcoatl (literally Bird-Serpent, or Feathered Serpent). Elected king in AD 977, he was defeated by his enemy Tezcalipoca and had to leave the city. Tezcalipoca's reign was marked by his adoption of the practice of human sacrifices. As for Quetzalcoatl,

the Aztecs believed that he set off across the ocean, sailing towards the East, promising to return. This belief was so strongly held that Moctezuma, on learning that Cortéz had landed, thought that the god had returned and welcomed him warmly.

Historically, one thing is certain. Someone called Quetzalcoatl led a group of warriors from the Highlands as far as Chichén Itzá in Yucatán. A Maya-Toltec kingdom was founded between AD 967 and 987. From this time, features that are purely Toltec can be found in the architecture of Chichén Itzá, such as the statue-columns (Fig. 50) and the stone effigies of a sleeping deity, his head turned to one side, known as Chac-Mool. The Mayas translated the name Quetzalcoatl, which became Kukulcán (kukul=bird, cán=serpent).

After the ruin of Tula, some of its inhabitants founded small towns around Mexico City. One of them, Cholula, flourished. Possibly the small groups speaking the Nahuatl, settled on the border of the state of Oaxaca, or to the south of it, may be Toltecs of diaspora.

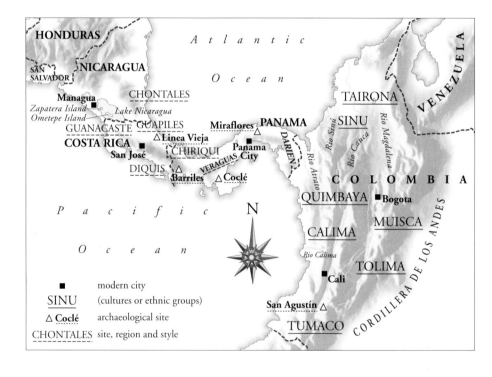

HONDURAS

Atlantic

SAN SALVADOR

NICARAGUA

Ocean

Managua

CHONTALES

Zapatera Island

Ometepe Island

Lake Nicaragua

GUANACASTE GUAPILES

Miraflores PANAMA

TAIRONA

SINU

VENEZUELA

COSTA RICA

△ Linea Vieja

San José

CHIRIQUI

Panama City

Panama

DARIEN

Rio Sinú

Rio Cauca

Rio Magdalena

DIQUIS △

VERAGUAS

Barriles △ Coclé

Rio Atrato

COLOMBIA

Pacific

N

QUIMBAYA

■ Bogota

ANDES

Ocean

CALIMA

MUISCA

Rio Calima

TOLIMA

LOS

DE

■ modern city

SINU (cultures or ethnic groups)

△ Coclé archaeological site

CHONTALES site, region and style

■ Cali

San Agustín △

TUMACO

CORDILLERA

VII. Central America

As a corridor through which Asian immigrants would have had to pass during their long march from Alaska to Patagonia, Central America is extraordinarily rich in relics of the past. The smallest antique dealer in the United States would have a small piece of ceramic from Costa Rica, or a jewel made of *tumbaga* (an alloy of gold and copper) from Panama. However, before the recent exhibitions, and M.J. Snarskis' remarkable catalogues, very few general works on the pre-Columbian arts have devoted much space to the very varied style centres which developed between Lake Nicaragua and the Darien.

Central America has the distinctive feature, despite its narrowness, of being divided lengthwise by a ridge of mountains, or rather a succession of *cordilleras* of volcanic origin (map Fig. 51. Central America and northern Colombia form a cultural zone called the 'intermediary region'. The South American influence was felt in Panama and the South of Costa Rica, whereas Nicaragua had more in common with Mesoamerica). The Atlantic side of the mountains is rainy, and used to be covered by a thick tropical forest, large parts of which remain. In contrast, the Pacific side is drier and less densely forested.

It was only towards 1950 that scientifically-based archaeological excavations were carried out, after centuries of profitable treasure hunts.

At this time specialists divided prehistory into six periods. Ceramics appeared among agriculturalists from the end of period III (4000–1000 BC). Period IV (1000 BC–AD 500) saw two-colour vases coexisting with anthropomorphic vases depicting hunchbacks.

Fig. 51
Geographic map.

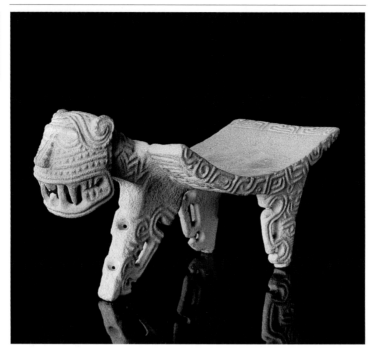

Fig. 52
Millstone (*metate*)
in volcanic stone
(andesite). An
identical stone has
been found in the
island of Ometepe in
Lake Nicaragua. This
shape and decoration
were common
on the Pacific side
of Nicaragua
and Costa Rica.
1st millennium AD.
Length: 60 cm.
Inv. 521-10.

These reveal a remote resemblance to the proto-Maya art, and also the ceramic figures of north-west Mexico. From the second half of the period, *metates* (millstones for grinding grain) and jade pendants were common in the north of Costa Rica. Some archaeologists believe these *metates* (a utensil still used today) were seats reserved for important people, when they were decorated with a profusion of animals (often, they are even shaped like animals) and with curvilinear motifs (Fig. 52). The jade pendants, a material undoubtedly exported from Guatemala and Guerrero, were generally axe-shaped and engraved to resemble a bird or a human being. Broadly speaking, the relations of Nicaragua (which had many Mexican immigrants) and the north of Costa Rica with Mesoamerica were obvious and would continue. In Nicaragua, the anthropomorphic stone statuary can basically be divided into two styles: that of the Pacific side and the islands of Lake Nicaragua (Fig. 53) and that of the district of Chontales, in the centre of the country.

The latter was simpler, consisting of a trunk with four wasted limbs, tucked under the body, and a round or rectangular flat head with bulging eyes.

The Diquís (in the South-West of Costa Rica) followed the same

fate as Panama: it was, culturally speaking, a dependency of north Colombia and the Chibcha languages were spoken in some places. From period V (AD 500–1000) pendants made of gold or *tumbaga* were regularly placed in tombs. During the same period the polychrome ceramics of Nicoya combined the sumptuousness of painted decoration with plastic elegance, as found in the ornamentation of the prestigious artefacts that were the *metates*. This pottery reveals a certain affinity with that of Panama, coming from the Veraguas-Cocle styles which were seeing a return to the portrayal of fabulous beasts such as the 'Crocodile-God'. This can be found on a gold disc reproduced in the following chapter (Fig. 59).

During period VI (AD 1000–1500) volcanic stone statues (Fig. 54), sometimes life-size, were made on the Atlantic side of Costa Rica. Their naturalism contrasts with the two-dimensional design of the effigies of the Jaguar-God found only in the Diquís region, and which are also classified in period VI, the latest period (Fig. 55).

Panama was not outdone by Nicaragua or Costa Rica in great lithic statuary. Huge anthropomorphic statues, at least a thousand years old were found in the Chiriquí and attributed to the 'Barriles' culture. They were however very few in number in comparison with those discovered on the Atlantic side of Costa Rica, which can be found in all the large public or private collections in the Western World. These come in all sizes, as do the *metates*, many of which do not have the curved shape needed for grinding grain, and are really tables for offerings, or seats of honour.

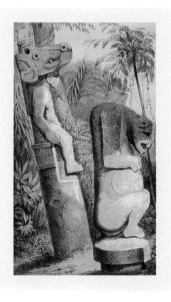

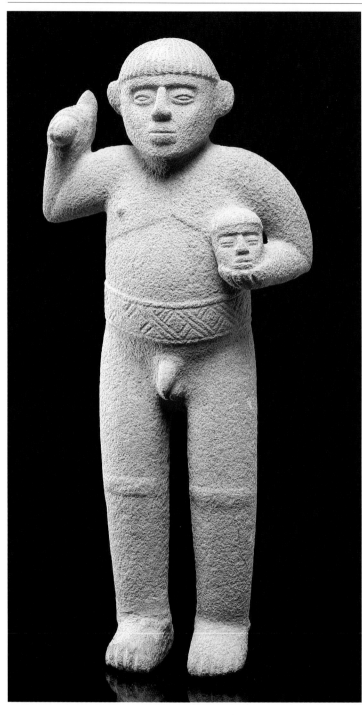

Fig. 54
Volcanic stone
statue, portraying
a person holding
a knife in one hand
and a human head
in the other.
Costa Rica.
Guapiles region.
Period VI. Between
AD 800–1300.
Height: 83 cm.
Inv. 521-4.

Fig. 55
Effigy of the Jaguar-
God in red stone.
Diquís style.
AD 1000–1500.
Height: 50 cm.
Inv. 521-5.
Acquired in Paris
from Joseph
Brummer by
Josef Mueller in the
early twenties.

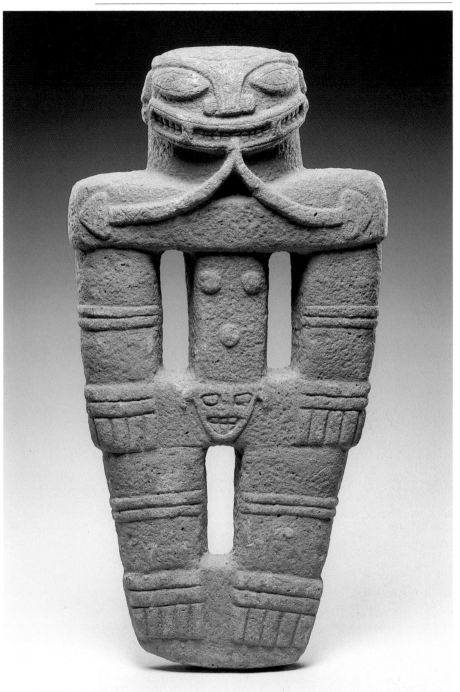

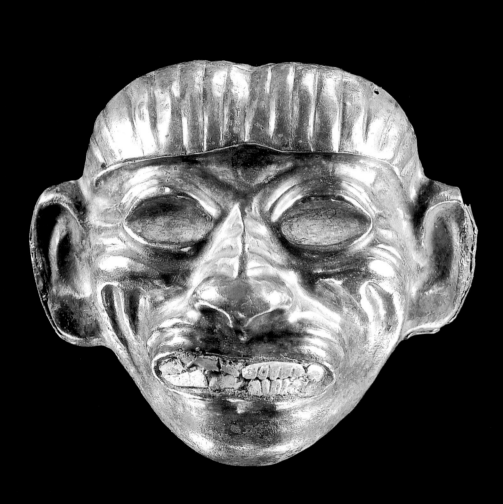

VIII. Gold and the Goldsmiths' Art
in the New World

Contrary to a generally held idea, which would like to attribute all innovations to the so-called 'Chavín' culture, the earliest traces of metal work were found in the southern Andes. We have seen (in the chapter dedicated to the cultures of the Forests of the East in the USA) that some archaic societies used native copper to make votive plaques or hammered ornaments. This activity cannot be defined as metallurgy.

The First Peruvian Goldsmiths

Gold extraction, smelting and the production of small religious arte-facts, appeared about 2000 BC in Andahuaylas, near Cuzco. The extraction of and work with copper only began a thousand years later, when gold started to become known in northern Peru. For sev-eral centuries, the Chavín knew only this precious metal, naturally mixed with about 5% or 10% silver.

In about 700 BC, the Chavín and Cupisnique, a twin culture, dis-covered copper. Both metals were worked by hammering, and jew-ellery was made from them in repoussé style. It was in Peru that the first three-dimensional metal objects were created, using the solder-ing or the 'lost wax' technique (Fig. 56). This technique consisted of modelling the desired form in wax, encasing it in a clay mould, heat-ing the mould until the wax melted, and pouring in the molten metal via ducts cut into the mould to drain the wax.

The Mochicas from the river Moche, mentioned later in the chapter on the Andes, were heirs to the Vicús culture, and would demon-strate their mastery of various other techniques: filigree, granulation, and the making of an alloy of gold and copper to lower the melting

Fig. 56
This hollow silver head belongs to a necklace. Mochica silver jewels are more uncommon than the gold ones. The goldsmith has gathered two halves soldering them. The expressive face recalls that of an old man (the deceased?). It is a funerary jewel. North Peru. Mochica. About AD 200–400. Height: 6 cm. Inv. 532-32

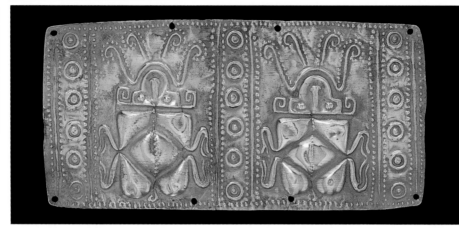

Fig. 57
In this Karchi gold plate, hammered, there are geometrical patterns all around two animals not easily identifiable. Maybe this jewel was clipped to a ceremony vest? Around AD 700–900. Length: 21.5 cm. Inv. 537-5.

point and thus create more solid objects (this alloy was called *tumbaga*). In the tomb of the 'Lord of Sipán', the high rank of the Mochica princes was emphasised by the profusion and refinement of the gold ornaments (see Fig. 70 later).

The Treasures of Ecuador and Colombia

The most northerly peoples, in Ecuador (Fig. 57) and Colombia, surpassed all others in their skills as goldsmiths. We still do not know their identity, and when we speak of, for example, Tolima or Calima, we are often referring to regions (see map Fig. 51 in the previous chapter). We know for sure however that the Quimbaya existed, even if we know very little about their everyday culture or their beliefs. They gained long-lasting celebrity through their 'Treasure of the Quimbayas', discovered in 1891 and given to Spain by the Colombian government, on the occasion of the Fourth Centenary of Columbus' voyage. These 121 pieces occupy the place of honour in the Museo de America in Madrid. Most of them, in *tumbaga*, are hollow figures, produced using the 'lost wax' technique, and were used as lime flasks. After being cast and removed from the mould, the surfaces were carefully polished and certain acids were used to remove the top layer of copper particles, so that the object looked as if it were made of pure gold.

Meanwhile, in the island of La Tolita in Ecuador, at the beginning of the Christian Era at the latest, other goldsmiths were expanding their repertoire of known techniques. They laminated, annealed and soldered, and also used the already familiar techniques of hammering and casting with 'lost wax'. They were the first people in the

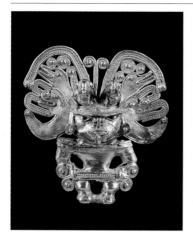
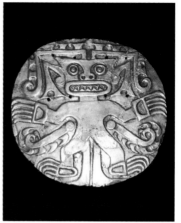

Fig. 58
Pendant in *tumbaga*, an alloy of copper and gold, cast in lost wax, depicting a 'cacique' or chief, probably endowed with the powers of a shaman as indicated by the two birds on his head. Colombia. Tairona. AD 1000–1300. Height: 7 cm. Inv. 531-3.

Fig. 59
Hammered gold disc, worn on the stomach (there are two small holes for hanging) by high-ranking warriors. The decoration features the so-called 'Crocodile-God' deity. Ritually smashed as a funerary offering (repaired). Panama. Coclé style. AD 800–1100. Diameter: 13.5 cm. Inv. 521-38.

world to work with platinum, which only appeared in Europe in the 18th century! The artefacts which they produced were exported to Peru and certainly helped to stimulate the Vicús and Mochica cultures.

Almost all the groups in the north of the Andes were or would become brilliant jewel-makers, producing either jewellery for wearing, as did the Tairona and the Sinú, or creating votive artefacts, as favoured by the Muisca.

This taste for precious metal gave birth to the legend of the Golden King, and of the country of Eldorado. In the colonial era, Europeans and Indians zealously competed with each other to find buried treasures. Thousands of kilograms of precious objects, particularly so in our eyes because of their cultural value, were melted.

The North Colombian goldsmiths taught their art to neighbouring peoples in Panama (who still speak Chibcha dialects today) and also in southern Costa Rica. The very name Costa Rica indicates the great value of the treasures that the European adventurers looted from that country. In general, the objects cast in 'lost wax' were made from *tumbaga* (Fig. 58) as the presence of copper lowers the melting point of the metal. In contrast, the funerary masks, and discs worn as pectorals (Fig. 59) were created by hammering and decorated in repoussé style.

Later, the taste for gold finery spread from Central America and became established in Mesoamerica, where the Olmecs and the Mayas had always preferred jade and hard stones. In the 'postclassic' era, the Mixtecs became skilled smelters and it was they who were responsible for supplying Aztec nobles with precious jewels.

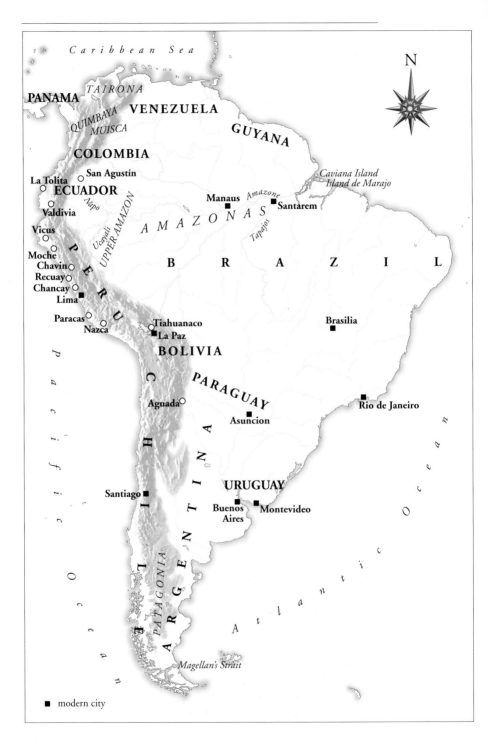

Caribbean Sea

N

PANAMA
TAIRONA
VENEZUELA
QUIMBAYA
MUISCA
GUYANA
COLOMBIA
La Tolita San Agustín
ECUADOR
Napo
Valdivia
Vicus
UPPER AMAZON
Ucayali
Moche
Chavin
Recuay
Chancay
Lima
P E R U
Paracas
Nazca
Manaus Amazone Santarem
A M A Z O N A S
Tapajos
B R A Z I L
Caviana Island
Island de Marajo
Tiahuanaco
La Paz
BOLIVIA
Brasilia
Aguada
PARAGUAY
Asuncion
Rio de Janeiro
Santiago
URUGUAY
Buenos Montevideo
Aires
C H I L E
A R G E N T I N A
PATAGONIA
Pacific Ocean
Atlantic Ocean
Magellan's Strait

■ modern city

76

IX. Peru
The Apogee of Art in the Andes

Geography and History in the Andes

The *Cordillera* range of the Andes Mountains stretches along the entire length of South America, not far from the Pacific Coast, mostly in the form of two parallel mountain chains, from Colombia to Cape Horn (map, Fig. 60). Its average altitude is 3000 metres, with the tallest peaks reaching heights of between 4000 and 6768 metres. This natural rampart cuts off the narrow plain bordering the Pacific, from the Amazon basin and, further south, from the Argentine Pampas.

The entire Peruvian coast is broken up by short valleys, transformed into oases by the floods arising when the snow in the Andes melts. Every year, new discoveries are unearthed which modify our picture of a wealth almost unique in the world. The history of the Andean cultures began with the production of modest stone tools, about 20,000 BC. Sixteen thousand years later, the first attempts at cotton-weaving took place in northern Peru (Huaca Prieta). The motifs on these fabrics heralded those of Chavín with the animal motifs already showing very clear signs of Andean influence. While it appears to have been unknown in Peru at this early stage, the art of pottery was practised in Valdivia in Ecuador and, with the exception of some wall-paintings, the figurines produced there (Fig. 61) are currently the oldest 'works of art' in the Americas.

'The Chavín Horizon'

We are indebted to the archaeologist, Julio Tello, an Andean Indian who in 1929 identified the civilisation in the centre-north of Peru, named after the site of Chavín de Huantar. The temples found on

Fig. 60
Map of South
America.

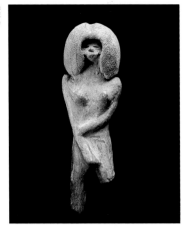

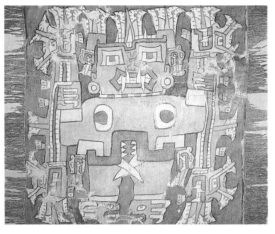

this site are the most important stone monuments and the most typical of a style which would spread to the centre (Ancón culture) and the south, where Chavín motifs have been found in Paracas. The religious themes came from a sacred bestiary where the mythical, sometimes winged, 'feline God' gradually changed into a human figure (Fig. 62) with the mouth of a wildcat and protruding fangs, feet in the shape of eagle's talons and hair in tufts. These can be directly compared to the serpents on the head of a figure painted on a bowl from Paracas (see Fig. 66 later). Some of these images inevitably bring to mind the 'Jaguar-God' of the Mexican Olmecs, as the two civilisations were contemporaneous.

Myths and metaphors lie behind the motifs which infiltrate the art of the temple-builders. At Chavín de Huantar, stelae and tombstones were decorated with bas-relief images of fabulous composite beings. A constant feature is the long curved fangs in their mouths. This early lapidary art was directed towards reliefs in Chavín rather than sculptures in the round, while the opposite was true in the neighbouring and contemporary complex of Cupisnique. The lapidaries also produced some rare small portable objects (Fig. 64). It would only be seen again (in its monumental form) in the centre of Peru (Recuay), in Colombia (San Agustín in the upper courtyard of the Rio Magdalena) and around Lake Titicaca. Chavín ceramics were typified by their vases (Fig. 63) which have very distinctively shaped necks, known as 'stirrup spout' and are decorated in a relief of animal motifs. This style is also seen in the ceramics of Cupisnique, being immediately recognisable by the wider, squat necks, which seem to have been squashed down. Sometimes the decoration

Fig. 61
Pottery figurine belonging to the 'Valdivia' culture which started in the 3rd millennium BC. Ecuador. About 2000 BC. Height: 8.9 cm. Inv. 537-1.

Fig. 62
Cotton fabric with painted decoration, depicting a deity with the body of a human and the mouth of a cat. Chavín (from the southern coast?). First half of the 1st millennium BC. Courtesy of the Merrin Gallery, New York.

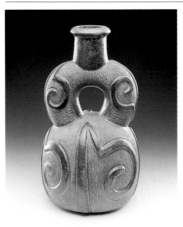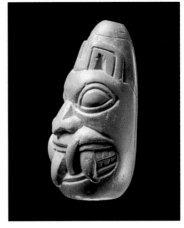

depicts a jaguar modelled in realistic style; other times it is reduced to undecipherable voluted scrolls.

Finally, we should mention that the skill of hammering gold was known from the earliest days of this cultural complex, in the middle of the 2nd millennium, in accordance with a technique which probably originated in southern Peru. This skill was discovered before the art of working copper (see chapter VIII on the origins of the goldsmiths' art).

The Culture of Paracas

Some incredibly rich tombs have been discovered in the desert region extending to the south of the Cañete River, and in particular between Paracas and Ica. The earliest of these are in the form of a well or cave, from which arose their name of *cavernas*. This 'Paracas Cavernas' period began in the first half of the 1st millennium BC and was greatly influenced by the Chavín style. The materials of the period were decorated fairly modestly, but some ceramics stand out because of their coloured decoration (polychromy was always one of the most striking features of the South Peruvian cultures). The decoration was achieved by using colours mixed with resinous fixatives, applied after firing. This process had been invented several centuries earlier in Ecuador (Fig. 66), and was also known in northern Peru to the Chavín culture of Jequetepeque.

In the second half of the 2nd millennium, the 'Cavernas' phase changed. From then on the Paracas tombs became veritable underground villages, necropolises with staircases leading to chambers linked to one another. It is this that gave the period its name of

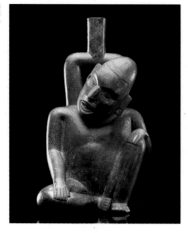

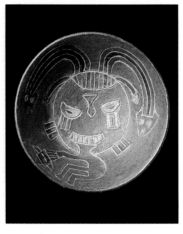

Fig. 65
The 'Chavín'
period ends
in local cultures,
such as Cupisnique.
In the illustration,
a vase-personage.
Peru. Cupisnique.
800–400 B.C
Height: 28.7 cm.
Inv. 52-70.

Fig. 66
Clay cup. Polychrome
decoration carried
out after firing. The
main figure has two
serpents on his head
and is holding a
severed head in his
hands. Peru. 'Paracas
Cavernas' period.
About 700–200 BC.
Diameter: 13.8 cm.
Inv. 532-45.

'Paracas Necropolis'. This phase would become famous for its truly sumptuous fabrics, which enveloped the mummified corpses of high-ranking figures. These were fine and moving offerings, woven and embroidered with mythological motifs in vibrant colours on a black background. They were found intact, thanks to the extreme dryness of the coastal desert, as were the fabrics of the Nazca culture which succeeded this one.

At the beginning of the Christian Era the 'formative' epoch, which consisted of the 'Chavín horizon' and the two south Peruvian Paracas phases, gave way to several cultural developments, or 'classic regional' cultures. We will limit ourselves to mentioning three of these cultures, each of which undoubtedly deserves to be called a 'civilisation'. These are: the Mochica culture in the coastal region in the north (the name came from the language spoken in the Moche Valley at the time of the arrival of the Spaniards); in the centre the Recuay culture (a village not far from Chavín de Huantar, in the Highlands); and in the south the culture named after the small river Nazca and the valley of the same name, near Ica.

The Nazca Culture

We know that the 'Paracas Necropolis' culture lasted for several centuries, developing into a 'proto-Nazca' culture which, like the Paracas, revealed a similar lack of stone statuary, the same abundance of fabrics (combining cotton and wool, weaving techniques, crochet, tapestry and embroidery) and pottery. The pottery, all for funerary purposes, was produced in large quantities and for this reason the Nazca culture is one of the most popular and best-known in pre-

Columbian America. Initially, the vases were decorated with fairly simple, naturalist motifs in sober colours fixed during firing. This style developed into more elaborate compositions, covering the whole surface of receptacles, which were sometimes made with a double spout linked by a handle. The design was outlined in black and they were painted in colours including ochre, brown, yellow and white. Eventually, the animal or anthropomorphic motifs decomposed so as to become almost unidentifiable. Moreover, in contrast to the south Peruvian traditions which concentrated on the pictorial rather than plastic arts, the Nazcas produced genuine sculptures, in the form of clay vases (Fig. 67) depicting figures seated (priests or shamans?) and even female figurines made completely of white clay.

However, in about the 6th century AD, the Nazca culture faded away.

The Mochica Culture

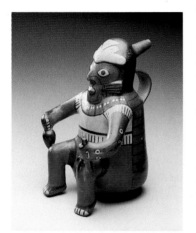

In the same period, almost directly to the north of the coastal region and nearly a thousand kilometres from the Nazca Valley, another brilliant civilisation appeared. It was descended from the Chavín cultures of the region, in particular the Cupisnique, whose stirrup-spouted vases it would perfect and make into impressive sculptures in the round. Its origins were discovered in Cerro Vicús, which gave its name to the pre-Mochica culture of Vicús, who were renowned for the talent of their metallurgists — the Mochicas would themselves create a mass of votive or funerary objects (see Fig. 70), and jewellery for daily use, in alloys of copper and gold.

Mochica pottery provided us with more vases decorated with painted scenes and others in the shape of human heads, almost life-size (Fig. 68). Their naturalism has led to their being classified as 'portraits' (of the deceased himself, his relations or servants of the dead man).

Did the Mochicas create an actual empire, or a confederation of 'chiefdoms', as in the case of the Great Chimú, a thousand years later, in the same valleys which surround the modern Trujillo? This question remains unanswered. However, a lucky discovery in 1988 confirmed what we had imagined: the sumptuousness and complexity of a funerary art that we knew of from precious ornaments which had been looted from tombs. (Tomb-looting was carried out by one

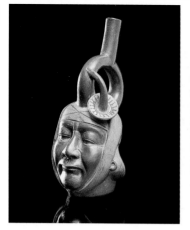

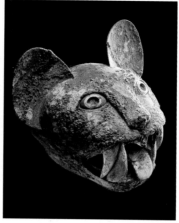

Fig. 68
Portrait-vase in ceramic, cast and touched up by hand. The 'stirrup-spout' vase was inherited from the Chavín tradition. Peru. Late Mochica period. First centuries AD. Height: 23.9 cm. Inv. 532-62.

generation after the other for centuries.) In this case, however, Peruvian scholars managed to intervene before the main tomb was opened. The 'Lord of Sipán' had lain there for fifteen centuries, covered with jewellery made of gold or silver, turquoise and shells set in amazing settings (Fig. 70). Around him lay members of his household, wives or servants, sacrificed to serve him in the beyond. Brilliant goldsmiths and metal-workers (Fig. 69), talented sculptors of clay, but uninterested in sculpting stone or using it for architectural purposes, the Mochicas built their temples in the form of stepped, rectangular-shaped pyramids. It has been calculated that one of the largest of these, which is badly damaged but can still be seen near the mouth of the Moche River, was originally 288 metres long, 136 metres wide and 48 metres high. It would have taken 50 million bricks made of clay mixed with straw and dried in the sun (*adobe*) to build it.

Fig. 69
Head of feline made of an alloy of gold, silver and copper, for ritual or funerary use. The fangs are made of shells and the eyes of stone and shell. Mochica. Peru. First centuries AD. Height: 18 cm. Inv. 532-78.

Recuay Culture

The third classic regional culture examined here, the so-called 'Recuay' culture, introduced a new creation: funerary chambers built using large properly fitting stone slabs. In contrast to the Mochica or Nazca civilisations, Recuay was not based in a typical coastal complex, nor just confined to the Highlands, but has been found dotted all over the centre of Peru. The real originality of the Recuay culture lies in its building of fairly large stone statues, some of which appear to depict military leaders carrying arms, while others consisted of a block in which the limbs and the face are lightly sketched in relief (Fig. 71).

Fig. 70
View of the 'Lord of
Sipán' tomb, a good
illustration of the
Mochica chiefs and
the talent of the
goldsmiths and
artisans working
for them.
Photo Heinz Plenge.

Fig. 71
Stone statue in
typical Recuay style.
Huaraz region. Peru.
AD 100–700.
Height: 73 cm.
Inv. 532-54.

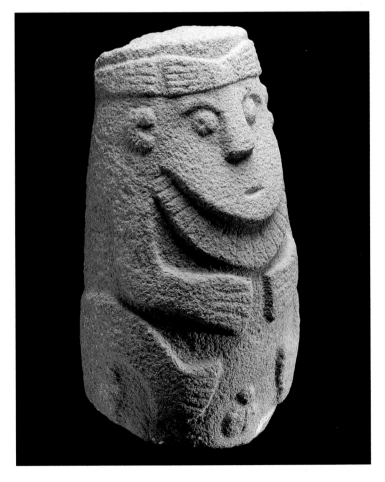

The Tiahuanaco Culture

Born on the shores of Lake Titicaca, at the beginning of the Christian Era, the Tiahuanaco culture came from the so-called 'Pucara' culture, which appears to have fostered mutual relations with the coastal culture of Nazca. The great eponymous urban and holy centre in Bolivia made the Tiahuanaco culture famous. This culture consisted of several structures, or temples, spread over several centuries, decorated with statues, including the beautiful 'Ponce monolithic' structure. A series of winged characters, shown in profile, are sculpted in light relief on the 'Gateway of the Sun', together with a larger figure shown face on, also holding staffs (Fig. 73). The deity holding the sceptres (which sometimes have serpents' heads) is part of the Chavín heritage. It lasted through the centuries and was found as far afield as Argentina, in the decoration of black pottery vases from Aguada. The Tiahuanaco culture would flourish during what is known as the 'middle' period (AD 500–1000).

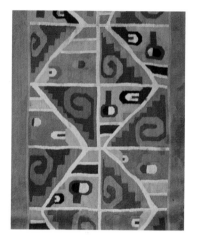

Fig. 72
Detail of a finely-woven cotton tunic. The pattern is difficult to make out but is derived from the motif of the 'winged angel with staffs' of Tiahuanaco. Huari. Peru. Between AD 700 and AD 1100. Inv. 532-22.

The Huari Empire and the Regional States

About the year AD 600, the 'regional cultures', a number of which have just been listed, were abruptly taken over by a new power, probably an empire preceding that of the Incas. This is known as a 'middle horizon' which succeeded the classic cultures. Numerous valleys in the north of the region were occupied by the Tiahuanaco culture, and a very uniform way of life and, no doubt, new religious beliefs, were imposed on them. The use of Nazca-style polychrome ceramics became more widespread at this time, among them the Recuay double receptacle, a utensil which continued to be used even by the Incas. Materials were also found, inspired by those of Tiahuanaco, the features of their figures so simplified that they could be seen as just geometric motifs (Fig. 72). About the year AD 1000, when the Huari influence weakened, the trends we have seen (painting in the south, plastic form in the north) became the origin of the different styles of the 'regional states'. For some five centuries, pre-Columbian Peru continued to give out its final glimmers of light... but what a firework display!

The 'Late Intermediary' Period: Chimú, Chancay and Inca

The Huari Empire had barely loosened its grip when the chiefdoms

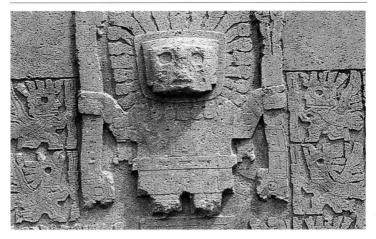

Fig. 73
The 'Staff God' from
the Gateway of the
Sun, in Tiahuanaco
(Bolivia).
Photo H. Stierlin.

in the Moche Valley joined together and eventually recognised the authority of one of the local princes. Thus the kingdom, or rather, the Confederation of the Great Chimú was born. By the time of the Inca conquest in the 15th century, this confederation would have extended its authority as far as the doorstep of present-day Lima in the South and up to the Ecuadorian border in the North. Numerous cities were founded in the most densely-populated valleys, and systems of canals and aqueducts were put in place to promote agriculture.

The Chimú King of Kings also built a capital, Chan-Chan (Sun-Sun) covering an area of twenty square kilometres. Built in clay mixed with straw, it is still an impressive site today, despite the half-dozen catastrophes (earthquakes and rainstorms as torrential as they are rare) recorded in the last four centuries.

Piles of jewellery and ornaments in gold, silver and gilded copper with inlays of semi-precious stones have been found in the ancient temples and tombs, as well as 'tomb markers', large wooden statues preserved by the dryness of the climate (Fig. 74).

When Pizarro arrived, the economy of Great Chimú, now become a simple Inca province, had evidently weakened. Its monarch was just one prince among many others, but a prince whose ancestors had reigned over a huge domain.

The Chancay Culture

The Chimú nobility may have recalled an encounter in the central coastal region with a power which had less influence but which, like the Chimú, had an original and relatively homogenous culture. The

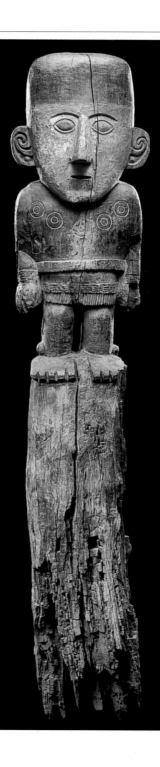

temples of stone and argil, in the north of Lima, are dotted over the valleys of Chillan and Chancay and it is the name of the latter that was chosen to designate the great urns and beige clay statuettes, embellished with brown-black patterns, which are typical of the 'Chancay culture'.

This pottery suffers a little in comparison with that of the Mochicas, or the Nazcas. The Chancay region is mainly renowned for providing us with quantities of high-quality funerary materials.

The Empire of the Incas

The word 'Inca' was a title designating the emperor and the male members of the imperial family. The chronicler Garcilaso de la Vega, born in 1539 in Cuzco to a Peruvian princess and a Spanish gentleman, is very explicit on the subject. The expression 'empire of the Incas' is therefore preferable to the 'Inca Empire', although the adjective 'Inca' is convenient and frequently used.

It is believed that the kingdom of Cuzco started with a small group of immigrants from the Amazon plains. In about the 13th century, the Cuzco princes held only the title of *sinchi*, or 'war leader'. Around 1430, taking advantage of the ageing Inca Viracocha (whose mummy was found by Garcilaso, one hundred years later!), the neighbouring Chancas launched a surprise attack on him. The Inca escaped, but one of his younger sons stood up to the attackers and easily beat them. The victorious prince was proclaimed Emperor Pacha Cutec.

Under his reign and that of his successor Tupac Yupanqui the Incas conquered a huge territory.

The Incas then had a chance to show off their organisational skills. A network of paved roads was built, with bridges over the gorges and ravines. Shops sprang up everywhere providing a place for patrols and merchants to stop for refreshment and a store where they could safely leave the goods they were transporting to Cuzco. The government's authority relied on bureaucratic tyranny.

The cult of Inti, the dynastic Sun God, was forcibly imposed on everybody, although regional gods were not banned or forbidden. The Incas were innovators in various areas. It was mainly their ambitions which made them stand out from their predecessors, together with their taste for the grandiose and the long-lasting. They were not the first people to build stone edifices, (the Huari Empire had done so and the Chavín culture before them) but they were the ones to cut enormous blocks of granite with such precision (Fig. 75). They

Fig. 74
Human effigy in hard wood, sculpted on top of a post (a tomb marker or 'idol' from a temple?).
Chimú. Peru.
AD 1200–1500.
Height: 1.10 m.
Inv. 532-69.

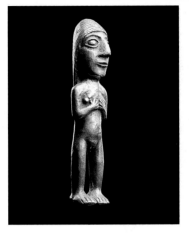

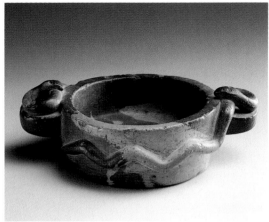

would create cities furnished with sewers, paved streets and public fountains, but did not erect monumental statues, and did not therefore follow the example of Tiahuanaco.

Garcilaso de la Vega, who left his native Peru at the age of 20, never to return, described nostalgically the royal gardens full of plants, fruits, gold and silver flowers, jewels and precious furniture (Fig. 76). He speaks highly of the luxury in which the sovereigns lived, and their multitudes of servants, which would have made the richest monarchs in Europe and the East green with envy. Pizarro's secretary, Jerez, listed the basins and gold vases that escaped the melting down of objects and jewellery which was carried out to pay the ransom for the Inca Atahualpa, who was assassinated after being released.

In the midst of such wealth, large statues pass unnoticed. Among the rare stone sculptures that can be definitely attributed to the Incas, and not to one of the numerous peoples forced into their huge empire, worth mentioning are the stone cups or vessels for cult purposes, sometimes circular or rectangular in shape (Fig. 77), and sometimes animal-shaped, like the small mortars for crushing coca leaves, depicting llamas or alpacas.

It is possible that one day, as happened in Sipán, a *cache* will reveal to us the treasures that Pizarro failed to discover.

This miracle would not however provide us with anything which could increase our admiration for the Andean civilisations and, in particular, for the last of these, which tragically died out in 1532, victim of our greed.

X. Art of the Amazon

Hunter-gatherers lived in the Amazon Basin from at least 10,000 BC (Fig. 78). From the 4th millennium BC, enormous mounds of shells provided primitive tools for the people who had built the mounds: semi-polished axes, scrapers, choppers, gems carved in stone or shell. Some of these mounds would also have contained slivers of crude pottery.

About 1000 BC, immigrants from Colombia or Venezuela, who had a basic knowledge of agriculture, settled in the Amazon Basin and on the island of Marajó. They brought with them the art of modelling and firing clay. These proto-agricultural potters were at the forefront of the Ananatuba phase in Marajó, which ended in 200 BC. They were gradually replaced by new arrivals, horticulturalists from the tropical forest, who also inhabited the island of Caviana. This was the Mangueiras phase, which ended about AD 100.

The following phase, still in Marajó, was called the Formiga period (AD 100–400). The pottery of this period seemed to regress however, in comparison with that of the Mangueiras phase. It was only during the following period, which was initiated by the arrival of people from sub-Andean regions, that a real revolution took place. This phase, known as the Marajoara period (AD 400–1350) was characterised by its unusual funerary rites. Bodies were buried temporarily, then the bones were exhumed and placed in a large ceramic urn before a 'secondary burial' took place. This practice is still current in certain tribal civilisations in South-East Asia and Oceania.

The funerary urns sometimes came in very large sizes (Fig. 79) and, from a technical point of view, were a real tour de force. It should be remembered that pre-Columbian America never discovered the pot-

91

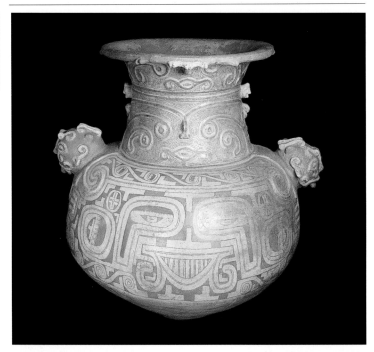

Fig. 79
Large funerary urn,
Marajoara style.
Polychrome pottery.
Brazil. Marajó island.
About AD 1000.
Height: 91 cm.
Inv. 534-28.

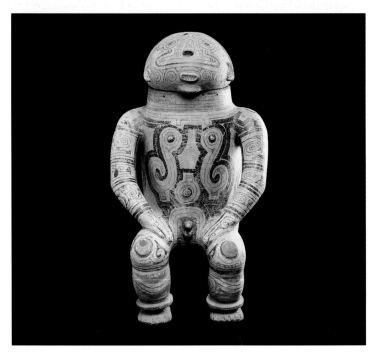

Fig. 80
Funerary urn
depicting a
high-ranking figure,
body covered in
painting, that can be
seen among
certain Brazilian
contemporary
Indians. Brazil. Island
of Caviana (?), near
Marajó, at the mouth
of the Amazon.
About AD 1000.
Height: 63 cm.
Inv. 534-30.

Fig. 81
Vase in beige
ceramic (restored)
from the Santarem
region. Brazil.
About AD 1200.
Height: 15.8 cm.
Inv. 534-26.

Fig. 82
Shipibo Indians
of Ucayali making
an anthropomorphic
jar. Peru.
High Amazon.
Photo A. and P.
Mathé. Archives
Barbier-Mueller.

ter's wheel and that the vases or receptacles were constructed using the coil method, snake-shaped pieces of clay, one on top of the other. The inhabitants of Marajó, whose island was partially submerged by terrible annual floods, gradually declined. The villages became scarcer and the pottery more modest.

The same fate awaited the inhabitants of the small neighbouring islands, including Caviana. Some astonishing funerary urns, depicting figures whose head served as the lid of the urn (Fig. 80), have been found here.

About 1350, the region was invaded by Indians from Guyana, the Aruas, who produced less elaborate urns for bones. They kept up their traditions until the 19th century, holding out resolutely against the sollicitations of the Portuguese colonialists.

If, thanks to modern excavations, the artefacts of Marajó, the Amazon Basin and the Upper Amazon are well-known, the same is not true for the 'Santarem' culture, which covered a vast area by the river Tapajos. Some amazing vases have been discovered but we have no idea when or where they were made. They show vague affinities with certain Caribbean ceramics (Fig. 81). These artefacts are small, as the prehistoric Tapajos did not carry out 'secondary burials' and so did not make funerary urns.

We will conclude this brief overview with a reference to the Shipibos, who live on the banks of the Ucayali River in the High Amazon of Peru (see map Fig. 60). This tribe still makes great anthropomorphic jars (Fig. 82), the form and decoration of which is similar to the pottery of the far-off Amazon Basin and completely unlike Andean traditions.

XI. A Better Understanding of Pre-Columbian Civilisations

The Supernatural

Among the so-called 'primitive' or 'archaic' peoples, religion was not limited to a small part of an individual's day. It governed every gesture, every action which might have disastrous consequences if it was not carried out in the appropriate way. Often, what was 'appropriate' was dictated by a myth. Before sowing seeds or starting to build a hut or a canoe, the peasant had to remember the action of the God, the fabulous Ancestor, or the civilising Hero who had shown how to sow seeds, how to build a dwelling place or how to cut down a tree to make a canoe.

The sacred or supernatural were constantly present. This explains the importance of the magician, the shaman or the priest who knew how to interpret the omens and knew the will of the gods. He could also draw up calendars, with unlucky days marked on it, carry out libations and sacrifices to appease the powers of the Beyond and cancel out the effects of a careless action or a violation of a law.

The Shaman

All magicians were not shamans. The latter (of which there were many in Siberia and the two Americas) did not just possess specific talents to counter the forces of evil or to unleash them against an enemy. They were also able to work themselves into a state of ecstasy, entering into a trance and transporting themselves to the Kingdom of the Spirits. There they would fight (for example) someone who had stolen a soul, the desertion of the body by the soul being seen as the primary cause of illness.

The shaman's powers (and the receptiveness of his entourage) led to

the taking of hallucinatory drugs, some of which (for example, the peyotl mushroom) are still widely used among certain groups. These drugs also include pulque, deified by the Totonacs of Veracruz, which is an alcoholic drink made from fermented agave juice.

Finally, the shaman had the power to transform himself into an animal. All images of a human being with animal features, such as the man-jaguar, the man-serpent or the man-bird should be seen as representations of a shaman or, more generally speaking, a legendary ancestor known for his magical powers. It is nevertheless possible that some of these images were portraits of deities.

Temporal Power and Religious Power

We should stress once again that in 'primitive' societies the authority of a community leader depended on the divine origin of his family, or on his personal abilities as a magician or leader in charge of communicating with the gods in the most developed societies (at that time the leader was also a priest).

The chief should be able to keep the respect of members of his community who might constantly be threatened by evil occult forces, identified or not.

When society expanded, the more stratified it became, the more the chief could surround himself with assistants, who would end up forming a priesthood, or a hereditary caste. The members of this clergy did not however devote themselves solely to meditation or practising cult activities, as in the large religions. They would carry out numerous rites to protect the community, appease the gods and other supernatural forces and thus preserve the cosmic harmony. This explains the human sacrifices in Mexico, which were to feed the raging thirst of the Sun God and ensure he would reappear every morning.

The Neolithic Civilisations

We have mentioned on several occasions the strange fact that Native Americans had long practised the art of metallurgy but still kept their stone tools and weapons (Fig. 83). This refusal to progress and take advantage of obvious benefits had been seen before: the Romans knew of the existence of the water-mill, but never constructed any of their own.

One of the reasons for the defeat of the Aztec troops by Cortéz (apart from all the political and moral aspects of this extraordinary event), was the fact that the Aztecs had 'swords' made of two planks

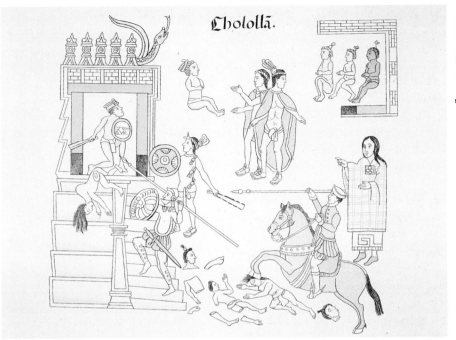

Cholollā.

Fig. 84
A drawing from the Llenzo of Tlaxcala, a post-Aztec manuscript. On the right we can see Cortéz on a horse and on the steps of the Temple of Cholula, a besieged Aztec city, and an Indian warrior, a Spanish ally, holding a shield and a wooden sword with an obsidian blade.

of wood with blades of obsidian (Fig. 84) in between them. This was a natural glass, volcanic in origin and easily breakable. Against an iron blade, the Aztec weapon was laughable. And yet, the Aztecs had jewellery made of gold and silver, and even bronze axes which they used as money and offerings to the gods...

From late Olmec times there was spectacular polished stone. Until the 16th century and even much later in less developed regions, arrow-tips and scrapers were made out of flint or obsidian, or other hard stones cut or hacked by means of brute force.

This indifference to metal as a means of progress is all the more surprising when one considers that the builders of the temples, sculptors of stelae and bas-reliefs and lumberjacks cutting down huge trees to make cultivable fields, must have dreamt of tools which were more effective than their stone axes and chisels. This is not the only area in which the pre-Columbian civilisations have surprised us!

97

Index

museu barbier-mueller
art precolombí

barcelona

Palau Nadal
Carrer Montcada 14, 08003 Barcelona
Tel. 93-3197603, Fax 93-2683938